ACRYLIC INNOVATION

ACRYLIC INNOVATION

Styles +
techniques
featuring 64
visionary
artists

NANCY REYNER • Author of *Acrylic Revolution*

NORTH LIGHT BOOKS
CINCINNATI, OHIO
www.artistsnetwork.com

 Other fine North Light Books are available from your local bookstore, art supply store or online. Also visit our website at www.fwmedia.com.

14 13 12 11 10 5 4 3 2 1

DISTRIBUTED IN CANADA BY FRASER DIRECT
100 Armstrong Avenue
Georgetown, ON, Canada L7G 5S4
Tel: (905) 877-4411

DISTRIBUTED IN THE U.K. AND EUROPE BY DAVID & CHARLES
Brunel House, Newton Abbot, Devon, TQ12 4PU, England
Tel: (+44) 1626 323200, Fax: (+44) 1626 323319
Email: postmaster@davidandcharles.co.uk

DISTRIBUTED IN AUSTRALIA BY CAPRICORN LINK
P.O. Box 704, S. Windsor NSW, 2756 Australia
Tel: (02) 4577-3555

Library of Congress Cataloging in Publication Data
Reyner, Nancy.
 Acrylic innovation : styles and techniques featuring 64 visionary artists / Nancy Reyner.-- 1st ed.
 p. cm.
 Includes index.
 ISBN 978-1-60061-864-2 (alk. paper)
 1. Acrylic painting--Technique. I. Title. II. Title: Styles and techniques featuring 64 visionary artists. III. Title: Styles and techniques featuring sixty four visionary artists.
 ND1535.R48 2010
 751.4'26--dc22
 2010018580

Edited by Kelly C. Messerly, Designed by Clare Finney, Production coordinated by Mark Griffin

About the Author

Born and raised on the East Coast in the United States, Nancy Reyner received a BFA from the Rhode Island School of Design and an MFA from Columbia University. Creating costumes and sets for theater and film to coordinating public arts programs for the state of New York, Reyner has had an expansive career in the arts, all of which inform her work. She now lives in Santa Fe, New Mexico, has been a painter for more than thirty years and exhibits and teaches both nationally and internationally. Her previous book, *Acrylic Revolution*, contains over one hundred acrylic painting techniques, and continues to be a best seller. Please visit her Web site, www.NancyReyner.com, for current work, her painting blog, workshops and gallery representation.

Author photo by Reynaldo Villalobos.

Artwork on Cover and Back Cover:

Gary Denmark, *Jongleur 2*, pictured again on page 116

Pat Forbes, (detail) *Neutrino Blossoms*, pictured in full on page 98

Catherine Mackey, (detail) *Harrison Street Scooter*, pictured in full on page 78

Beth Ames Swartz, (detail) *The Fire and the Rose: But Heard, Half-Heard, in the Stillness*, pictured in full on page 104

Jim Waid, *Blue Shimmy*, pictured again on page 74

Ines Kramer, *Rooftop Eden*, pictured again on page 63

Martha Kennedy, *Avocado on Orange*, pictured again on page 54

Robin Sierra, *Aquamarine*, pictured again on page 130

Renée Phillips, *Field of Dreams*, pictured again on page 50

Art on page 2:
Nancy Reyner, *Koi and River*, acrylic on canvas, 60" × 46" (152cm × 117cm)

Art on page 5:
Nancy Reyner, *Ocean Elixer*, acrylic and gold leaf on panel 20" × 20" (51cm × 51cm)

Metric Conversion Chart

To convert	to	multiply by
Inches	Centimeters	2.54
Centimeters	Inches	0.4
Feet	Centimeters	30.5
Centimeters	Feet	0.03
Yards	Meters	0.9
Meters	Yards	1.1

Acknowledgments

Special thanks to those who helped connect me with the extraordinary artists included in this book: George Alexander, Bruce Cody, Bill Hinsvark, Katherine Chang Liu, Michael Matassa, Keith Morant and Renee Phillips. Many thanks to Reynaldo Villalobos for photography. Thank you to Bonnie Teitelbaum, Tekla Johnson and Eve Munson for inspiration and assistance. Thank you Phillip Cohen and to my wonderful family and friends for support. I thank my art professors Phyllis Bramson, Jane Wilson and the late Art Wood for their wisdom and encouragement. I cherish my dance teacher, Lori Brody, and all my cool dancer friends in Brody's Ballerinas for making life wonderful. Thank you to Mark and Barbara Golden, and to the staff at Golden Artist Colors for all their wonderful inventions, products and support, with special thanks to their technical department. I have enjoyed immensely working with the F+W and North Light Books staff, with extra thanks to Jamie Markle and Kelly Messerly.

Dedication

This book is dedicated to my son, Jacob Cooper Cohen, who has been and continues to be a great inspiration for me.

TABLE OF CONTENTS

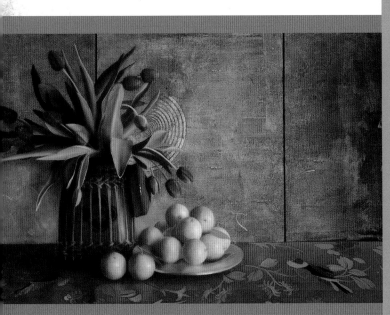

Sherry Loehr
Tulips and Oranges
Acrylic on board
24" × 36" (61cm × 91cm)

Gary Denmark
Jongleur 2
Acrylic and collage on board
48" × 48" (122cm × 122cm)

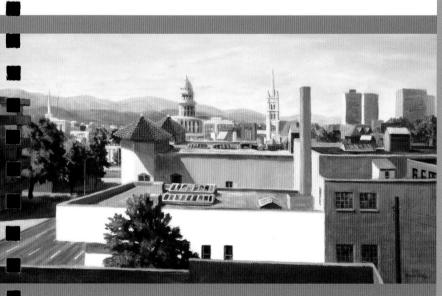

Bruce Cody
Capitol City Sunlight
Acrylic on canvas
16" × 30" (41cm × 76cm)

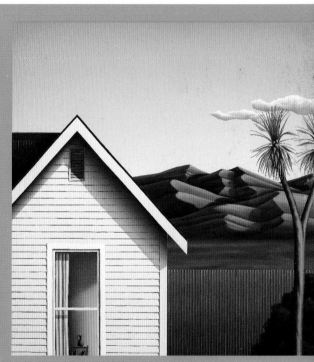

Hamish Allan
House and Hills
Acrylic on canvas
24" × 24" (61cm × 61cm)

Need an idea? Want new motivation? Desiring new tips and techniques? Just flip through the twenty-nine styles in this book ranging from photorealism to minimal color field and everything in between. Read how other artists have taken the journey to create unique and personal art, offering advice and gems from their own experience and encouraging artists to invent, not replicate. An artist's process can be viewed both mentally (the idea) and physically (the technique). A visionary artist develops and combines both to create a personal vision and unique art. This book is meant to inspire artists to find their own personal voice.

Throughout history the discovery of new art products spawned the invention of new art

it does best. New paint requires a new way of thinking. Acrylic has a wide range of possibilities, uses and techniques. My previous book, *Acrylic Revolution*, demonstrates this variety with over one hundred acrylic painting techniques in an easy resource format. More and more artists are choosing to paint in acrylic, and this growing trend is reflected in the new contemporary art styles emerging on the scene. This book contains incredible artwork from sixty-four acrylic artists worldwide, all contemporary, using acrylic in part or completely in their work, who are taking advantage of acrylic's potential to create unique genres or styles. This book addresses methods and techniques for finding your own personal voice in this medium.

INTRODUCTION: HOW TO USE THIS BOOK

To view a painting is to experience the idea of space.

styles, ideas and techniques. The creation of oil paint was a catalyst for new styles of blending and realism that were previously unheard of for the egg tempera painters of that time. The invention of storing oil paint in tubes added portability for painters, taking them out of the studio and paving the way for plein air and on-site painting. Photography, digital imagery and computers have also made their mark.

Acrylic paint, first developed in the 1930s, continued to improve in quality and durability, and eventually established itself as one of the most dependable, archival and permanent artist materials offered. Available to artists now for over sixty years, it is currently helping to push the envelope of contemporary vision. Acrylic is often used as a substitute for oil paint or watercolor. But the real gold mine for the artist is in allowing the medium freedom to do what

In this book I take a fresh stance by grouping styles in terms of their perceived spatial qualities, even inventing some of the style names. Notably, many artists in this book have work represented simultaneously in several style categories. A style is merely a tool, meant to facilitate the expression of an idea, and therefore most artists' work will not fit neatly into any specific category. A style is a tool, not a label.

To create an original idea, we can use the wide variety of visual stimuli around us every day, in advertisements and media, our relationships and experiences, objects, nature and architecture. All these can offer artistic references. Instead of replicating, art can be fresh and original when we add our own individuality, rearrange images, work with unusual combinations, and let materials and mediums influence us.

Nancy Reyner
Essence (detail)
Acrylic and gold leaf on panel
32" × 26" (81cm × 66cm)

ESSENTIAL ACRYLIC TIPS

- **Acrylic is available in a wide variety of paints and products.** It is helpful to understand the different categories of products to select the most appropriate one for the technique at hand. In general, acrylic paint color has two components: pigment (for color) and acrylic binder (also known as polymer). Usually, the binder is also called a medium, and, when thickeners are added, it's a gel. The fluid binder without thickeners is combined with pigment to make fluid paints. Binder with thickener added to pigment creates the heavy bodied paints. A small amount of whiting agent added to the binder creates matte products such as matte mediums, matte gels and matte varnishes. Larger quantities of whiting or opaque components make pastes. Adding materials such as pumice, glass beads, metal and fiber can make unusual gels. Any of these products can be used as a ground to change the painting surface, when applied as a first layer to customize and change the surface absorbency, texture or color.

- **Acrylic products are compatible with each other.** Any acrylic product can be combined together while wet to create new mixtures and hybrids. Gels, mediums and pastes can all be mixed together. Keep in mind that the characteristics of one particular paint or product will change when you mix it with another. This can work to your advantage; for example, mixing a gloss medium with a matte medium will produce an excellent semigloss. However, some specialty products, such as Clear Tar Gel, which makes the paint tar-like and stringy, will lose their special abilities when too much of another paint or product is added. You can also layer acrylic products and paints in any order in your painting process. Gels can go on top of mediums and mediums on gels. Diluted paint works on undiluted paint and vice versa. Glossy can go on top of matte, then on satin and on glossy again.

- **Acrylic can be used in combination with other mediums.** Most other mediums such as oil, gouache, watercolor, pastel or casein can be applied on top of acrylic grounds or acrylic underpaintings. In general, though, avoid using acrylic on top of other mediums, or combining other mediums together with acrylic in wet form. For example, watercolor can be used to wonderful effect on top of acrylic that is already dry, but mixing the two together wet is less effective.

- **A few acrylic products are best used alone.**
 1. Use acrylic gesso as a primer and not as a white paint. In thick applications, acrylic gesso may crack.
 2. Use a removable archival varnish as a final protective coat. Even though it can be used in the middle layers of a painting, it is meant to be removable for cleaning purposes and as a final coat.
 3. Additives such as retarder, thinners and flow release need to be used in correct proportions. It is always a good idea to read product labels for correct use and application information.

- **Acrylic is a glue.** Any acrylic paint or product can function very well as a glue. You can add collage elements and mixed media to acrylic while it's wet and they will adhere nicely.

- **Stir gently and don't shake.** The small amount of soap remaining in the acrylic products from processing may create bubbles with vigorous stirring or handling. To stir a batch of paint, use a palette knife instead of a stiff bristle brush. After stirring mediums for use in pours, let the bubbles settle out overnight before pouring.

- **In general, mix paint with a knife.** Brushes are meant to hold paint, while knives more easily release the paint. Mix a batch of paint with a knife for a clean, homogenized mixture. Use a brush to mix paint in a hodgepodge manner, for a painting technique called "dirty brushing."

- **As you paint, keep brushes in water** until you can clean them well with soap. Soap removes paint from the brush more effectively than water alone. If a brush in use is left out of water too long, the acrylic will dry on it, making it difficult to remove later. To make cleaning easier, slightly dampen the brush bristles with water before dipping them into the acrylic paint. Damp bristles reduce the gripping power of acrylic, making the paint easier to remove later.

- **There are two choices for thinning acrylic paint:** water or acrylic medium. Adding water will break down the acrylic binder in the paint, creating a thinner paint that appears like watercolor, resulting in a matte finish. The more water you add, the more the paint will be affected by the absorbency of the painting surface. On the other hand, adding acrylic mediums, gels or pastes, while minimizing the addition of water, will

maintain the acrylic's properties, offering a rich, glossy appearance. Either choice is effective, depending on your desired result.

- **Acrylic shrinks in volume while drying.** As acrylic dries, the paint layer will shrink by about a third in volume. This is more noticeable when using thick pastes and gels. Generally, apply a paint layer that is a little thicker than what you want at completion.

- **Acrylic appears lighter in color when wet.** The acrylic binder is naturally white when wet, but dries clear and glossy. Therefore while painting with acrylic, the color will appear lighter when wet but goes to its natural color when dry. The more mediums and gels you add to a paint color, the greater the difference between this lighter version when wet and its natural color when dry. Paint color added to pastes, however, will not change in color very much between wet and dry. That is because pastes are white when wet, remaining white when dry.

- **Acrylic is naturally glossy.** Matte products such as matte mediums, matte gels and matte varnishes have matting agent (a fine white powder) added to them to create their characteristic appearance. This matting agent means that matte products slightly cloud and lighten colors underneath. The thicker the application of a matte product, the more this cloudy and lightening effect will be apparent. Acrylic products labeled semi-gloss or satin have matting agent in them as well, just less in proportion to a matte product. Also, colored paints when dry will vary naturally in sheen, according to the pigment.

- **Acrylic has a two-part drying process.** The first part of the acrylic drying process, known as "dry to the touch," means the top layer of the paint skin has dried due to the evaporation of the water in the paint, enabling layering. The second part of the drying process involves the curing of the polymer or acrylic in the paint, which takes several days to several weeks to "lock down,"

or fully cure. The actual curing time is dependent on the layer's thickness and environmental factors. During this curing time, it is important to allow air to flow around it. Avoid tightly wrapping the painting, storing the artwork in a closed environment or exposing it to extreme temperatures during the curing phase.

- **Be aware of the "tacky phase."** While the paint is still wet, it is very malleable. You can scrape it, wipe it off and rework it with ease. As you continue to work into this wet paint, however, it is already beginning to dry. Once it dries to the touch, it has a wonderfully resistant surface on which you can overlay new paints without disturbing what is underneath. It is between the wet stage and this "dry to the touch" stage when problems can occur. Between the wet and dry stages, the acrylic gets tacky, and continued working over this tacky area can create unwanted effects such as streaking or pulling as the paint sticks to your brush. Initially, acrylic paint glides smoothly and easily, but as it reaches this tacky phase, it will begin to pull and feel difficult to manipulate. At this point, stop painting in that area, and move on to a drier area of the painting. If you need to keep working in the tacky area, use a blow-dryer for a minute to dry it quickly, then resume painting. Avoid blow-drying very thick layers. Also, be aware that the paint on your brush will dry quickly. Make a habit of rinsing frequently to keep the paint from getting tacky on your brush.

- **Do not freeze acrylic.** Oil painters sometimes freeze the excess paint on their palettes to prolong the life of the paint. Avoid this with acrylic. Acrylic contains a certain amount of antifreeze, but after a few freeze/thaw cycles, the paint will no longer be stable. Acrylic paintings, when fully cured, will be fine if exposed to cold. However, fine art should not be exposed to extreme temperatures. To extend the drying time of wet paint, consider using Golden's slow drying OPEN Acrylics.

THE REALISTIC WINDOW

Realism, convincing portrayals of the physical world, presents imagery that has fascinated artists and viewers for centuries, and continues in popularity today. Still life, landscape and portraiture are all just as potent today as they were in the past. This section includes five realistic styles, each using similar principles. These principles, popularized in the Renaissance, include singular or fixed perspective, the use of a horizon line, modeling of light and shadow to create volume, and the illusion of receding space, all of which turn the canvas into a viewing window. Inspired by evolving technologies in photography, digital imagery and new pigment development, realism has expanded to include hyperrealism, along with new techniques and exciting new color palettes. This section investigates both traditional and new realistic styles with an emphasis on keeping them personal and contemporary.

Jason de Graaf
Untitled (Self Portrait)
Acrylic on canvas
30" × 30" (76cm × 76cm)

An epic narrative style is characterized by multiple figures in a landscape—it's the "big scene" that has been used historically to convey weighty narratives such as religious stories and myths.

Paul Pletka's *Tears of the Lord* (page 15) is a new vision on the epic narrative. This striking piece uses a bold-colored, flat backdrop and a vibrant color palette to set off multiple figures, along with incredible attention to detail.

Pletka works in large formats for greater impact and has centered his work on his desire to explore the ritual side of Native American culture, to bring forth the spiritual side in a respectful way, and to consider this an interpretation from his own cultural point of view.

Pletka has painted for many years, working through his own personal desire to invent something original. Each painting is heavily researched to use authentic and accurate material. But for Pletka, making something beautiful is the most important aspect; therefore, some elements may be slightly compromised for aesthetics.

The Artist's Process

Two key motivations for Pletka are scale and a new technical challenge. He creates many thumbnail sketches until a cogent image emerges, then he moves directly to the canvas, drawing first with vine charcoal to transfer his energy and excitement into the work. He then overpaints the line work with Raw Sienna. Even with the initial drawing in place, Pletka will rearrange and redesign to accommodate a piece's evolution. He often obliterates a figure he painstakingly worked and repaints it in a new location, sometimes several times. To maintain the integrity of the canvas's surface, he sands or scrubs off an area, instead of overpainting. By working in acrylic, Pletka is able to maintain a sense of immediacy while working with multiple glaze layers on one painting at a time.

Other Art in This Style

- Contemporary artist Mark Tansey, Modern artist George Bellows
- Renaissance painters Sandro Botticelli, Masaccio, Leonardo da Vinci, Michelangelo Buonarroti, Titian, Tintoretto and Raphael
- Historic religious and mythic paintings from French Classicism and Baroque periods
- Fantastic imagery from Hieronymus Bosch
- Muralist Diego Rivera

TIPS from the Artist

Great art contains the artist's originality, which then shows through the work. Be willing to destroy elements in your work to push the piece further. Your work has to be you, it has to come from your core and be honest. It can't come from someone else and be successful. There are so many permutations available in this world that it's always possible to come up with a unique vision.

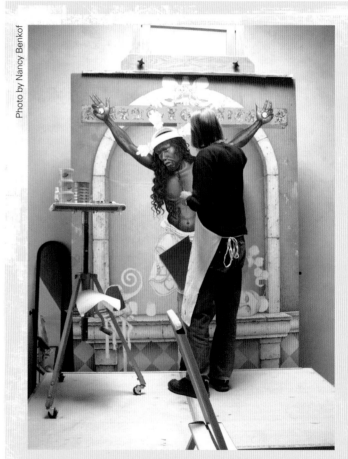

Photo by Nancy Benkof

For Pletka, inspiration comes from many trips across the Western United States, visiting museums, national parks and wildlife refuges, reading books and attending cultural events.

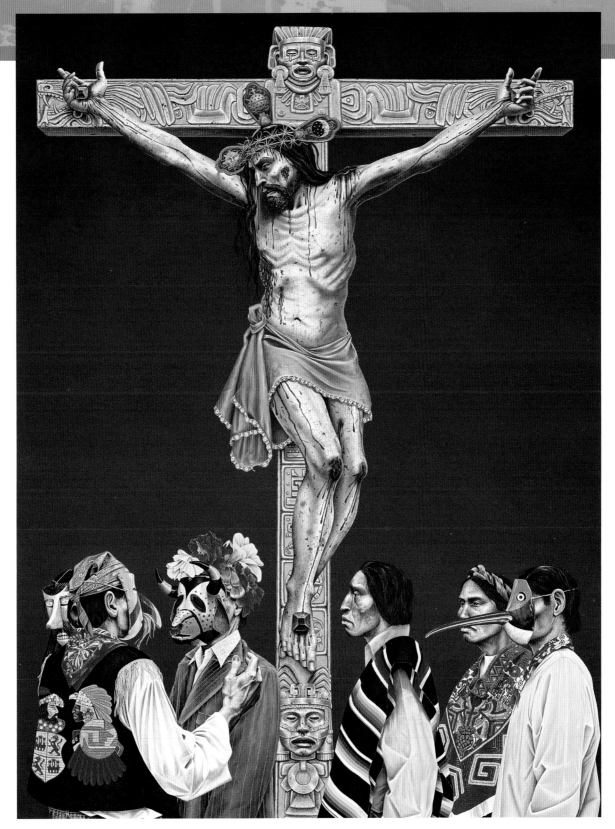

Paul Pletka

Tears of the Lord
Acrylic on linen canvas
96" × 72" (244cm × 183cm)
© copyright Paul Pletka, 2005
Courtesy of the Museum of the American
West, Autry National Center, Los Angeles

VARIATIONS ON EPIC NARRATIVE

Variation 1: Action and Narrative

A wide variety of strong colors and distorted proportions adds visual tension and movement to emphasize action and narrative.

Paul Pletka
The Revelation
Acrylic on linen canvas
44" × 66" (112cm × 168cm)
© copyright Paul Pletka, 2008
Private collection

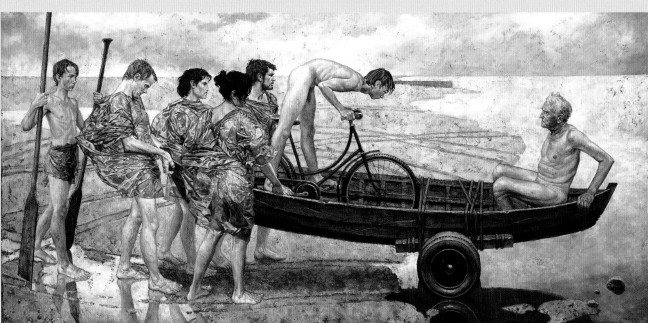

More Variations

- Use your own personal stories to paint scenes depicting memorable moments. Take liberties and change, rearrange and re-create to paint your ideal version. Paint yourself into new scenes you desire or fear. Using childhood photographs, replace figures or backgrounds with new ones. Change color palettes.

- Experiment with arrangements of multiple figures. Cut out figures, using a photocopier to reduce and enlarge for a variety of sizes. Place and arrange on various backgrounds from photographs, drawings or other paintings. Backgrounds can be as simple as a color field and as complex in detail as a photographic landscape.

Variation 2: Emphasize Mood

A limited palette with muted tones creates mystery and mood. The simplified and elegant background keeps the focus on the figures and narrative.

Daniel Barkley
Far Shore
Acrylic on canvas
52" × 114" (132cm × 290cm)

Epic narrative paintings combine multiple figures in a landscape, coordinating many forms in one image. These compositions rely heavily on tonal areas (shapes of light and dark) to create movement and focus.

Starting the painting with a tonal drawing gives you a jumpstart to the composition process. This technique transforms a drawing into tonal shapes, then seals and prepares it for subsequent paint layers.

Materials

- **Drawing Materials:** A variety of water-soluble and waterproof drawing materials (i.e., charcoal, Conté, graphite, water-soluble pencils), smudge stick, chamois, erasers
- **Surface:** Any primed surface
- **Painting Tools:** Painting knife with stepped handle, paintbrush
- **Other:** Acrylic polymer medium (matte), water

1. Create a Line Drawing

Make a drawing outlining the general areas to be painted, using a variety of drawing materials, both water-soluble and waterproof. Make sure to have at least one water-soluble item. Test it first on a scrap surface to see if the drawn line will blend when brushed over with water. Experiment by using a variety of line qualities; change your grip, vary the angle onto the surface, vary pressure applied, and smear lines using a smudge stick, eraser or chamois.

2. Create Tonal Areas Using Water and Medium

Dip a brush in water and/or acrylic medium. Apply the brush over the drawn lines, softly moving tones out along the surface to create softer edges and tonal areas. When applied over waterproof materials, such as graphite pencil, the line will not create tones. By using both waterproof and water-soluble materials in your drawing, you get more variations with this step. If you need to get some white areas back, selectively overpaint with gesso. In addition, experiment to see the differences using medium versus water. This step alone may suffice for sealing. If some lines, however, did not get painted with water or medium and are still water-soluble, continue to step 3 to seal the drawing completely.

3. Add a Waterproof Coating

Liberally pour an acrylic medium over the entire surface. If working on a large area, do this step in smaller sections. Using a painting knife with a stepped handle, gently spread an even coat of the acrylic medium over the drawing. Avoid scraping the surface by raising the knife about 1/8-inch (3mm) from the surface with the acrylic rolling out from under it. Keep the knife at a slight angle so it isn't parallel to the surface. If the knife keeps scraping the surface, apply more acrylic medium.

Photorealism relies on sharp detail, with super-real images incorporating photographic characteristics. Daniel Smith, photorealist wildlife painter, considers it a compliment when someone comments that his work is as good as a photo. Yet Smith goes even further. Making his paintings believably realistic while still able to stand alone as good works of art takes daring and creativity beyond copying a photograph. Too much emphasis on the story, however, can feel contrived, like an illustration. Even with his intent for portraying reality truthfully, Smith will stretch things a bit to enhance aesthetics when needed. Photographic images contain inherent limitations from the camera's depth of field, including distortion, compressed images and mixed focal ranges—blurring certain areas while leaving others crisp.

In *Zero Tolerance* (page 19), Smith transforms the work from photographic generality by adding his own compositional design, ideas and imagery, along with simplifying and editing detail. Here the image is enhanced by the addition of foreground dust, which reduces background detail and places the focus on the animals and action. The lionesses were photographed on one trip, while the elephant was from another. In addition to using multiple references, Smith researches animal behavior to get correct wildlife appearances and habitats. Smith has always been intrigued by wildlife, and has been painting this imagery since childhood.

The Artist's Process

Smith works on masonite boards, and rolls out his gesso primer to add a pebbly texture (good for rock textures).

> ### TIPS
> #### from the Artist

There's a difference between technical skill and turning it into a true work of art. Composition, a strong focal point, editing, balance, aesthetics and the right amount of negative space are all essential. There's a lifetime of experience that goes into it.

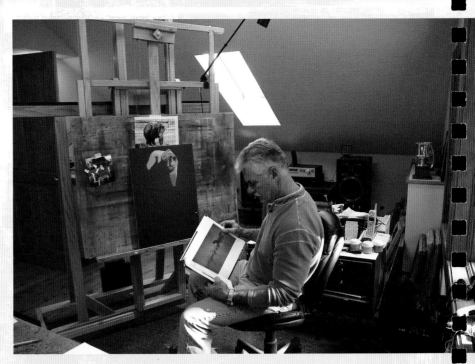

Smith lives near Yellowstone National Park where moose, elk, bear and fox are frequently visible. He also travels to places like Alaska, Africa, Glacier National Park and the Canadian Rockies to sketch and photograph. Firsthand experience is key for Smith, adding adventurous stories and personal relationships with the animals in his paintings.

Drawing and then underpainting gives Smith his jumpstart, whereupon many thin layers of paint are applied, along with drybrushing techniques. Keeping brushstrokes and texture to a minimum, the final surface is smooth and flat, reducing distraction from the exacting detail.

Other Art in This Style

- Wildlife painters Bob Kuhn, Robert Bateman and Carl Rungius
- Urban landscape painter Max Ferguson
- Photorealist Richard Estes
- The Dutch Masters

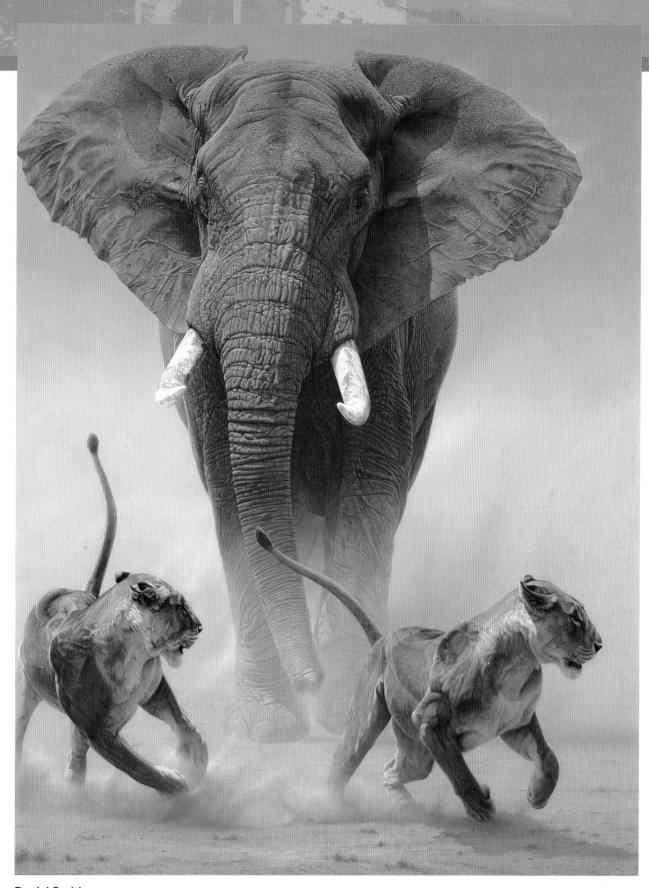

Daniel Smith
Zero Tolerance
Acrylic on Masonite
55" × 42" (140cm × 107cm)

Variation 1: Unexpected Juxtapositions

Unexpected juxtapositions add humor, making this realism more personal. A trademark for Palmore, stylistic plays between background and object creates surprises. Palmore's tip: Develop your own techniques so you don't paint like someone else.

Tom Palmore
Mugsy the Jungle Boy
Acrylic and oil on canvas
46" × 72" (117cm × 183cm)

Variation 2: The Real and the Surreal

Close-cropping, a hint of narrative, and an intent to make paintings more intriguing than photographs all add dramatic impact and a sense of the surreal. De Graaf consciously tries to paint things that haven't been done before.

Jason de Graaf
Vesalius Skeleton
Acrylic on canvas
24" × 36" (61cm × 91cm)

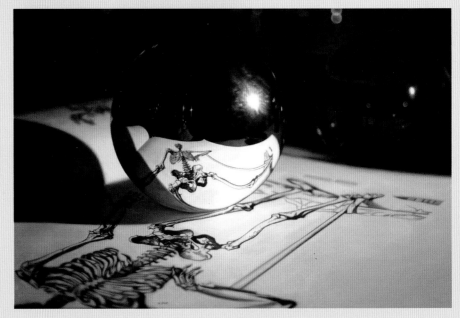

More Variations

- Our best work has roots in our everyday lives and past experiences. Spend time photographing your home, personal spaces and favorite places, friends and activities you like. Experiment by cutting and reassembling your photos to create new combinations.

- In a corner of a room, create your own stage set using fabric and add friends willing to pose with costumes and objects. Photograph this setup using different lighting and use it for a painting.

Photorealism demands exact painting techniques using extreme detail, perfect proportions and scale. Many realist painters enjoy the challenge of painting with minimal references and mostly imagination. Other painters take advantage of photographic processes in their paintings. This technique prints a color image directly onto an acrylic skin for use as an underpainting or collage element.

Tip

Instead of using gloss acrylic gel for a skin, try other acrylic products such as colored paint, matte gels or pastes to get an opaque or translucent skin. Consider using unusual papers such as aluminium foil.

Materials

- **Acrylic Products:** Any clear glossy acrylic gel, mineral spirits-based acrylic spray fixative
- **Surface:** A nonstick surface that will release acrylic (freezer paper—not wax paper, HDPE plastic, garbage bags or cheap plastic wrap—test first)
- **Painting Tools:** A squeegee tool (piece of cardboard or plasterer knife), sponge applicator, masking tape, paper
- **Other:** Clear digital coating product or ground for inkjet printing (i.e., inkAID or Golden's Digital Ground for Non-Porous Surfaces), ink-jet printer (with a flat feed, i.e., paper should enter in a different place than it exits)

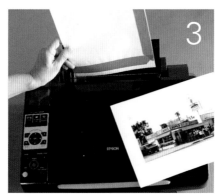

1. Make an Acrylic Skin

On a removable surface where acrylic will not stick, squeeze out a generous amount of gloss acrylic gel. Using a squeegee tool, spread the gel in an even layer about ¼-inch (6mm) thick. (Acrylic will shrink by 30 percent in volume. A thicker application will keep the dried skin from tearing.) Let this dry until the gel turns clear.

2. Coat and Prepare the Skin for Printing

While the skin is still on its surface, use a sponge applicator to apply a thin layer of digital ground. Let it dry for about an hour, or quick dry for a minute with a blow-dryer. Peel the skin off the surface and cut the skin to a size smaller than a sheet of regular-sized paper. Leaving about ½-inch (12mm) or more as a bottom margin, secure the skin onto a piece of paper with masking tape, along the bottom and on only one side where the printer grips the paper.

3. Print the Image Onto the Prepared Skin

Select an image (here, I'm using a photograph taken by Bruce Cody). If using an all-in-one printer, then place the image in the scanner. Otherwise, send the image through a computer, or use an attached scanner. Set the printer preferences for high quality and to print on gloss. Place the paper with taped skin into the printer's paper feed and print.

4. Secure With Fixative

Here the image is printed onto the clear glossy skin. Fix the image by using a mineral spirits-based acrylic spray fixative. If desired, you can paint on the back of the skin to change transparent areas to opaque, and/or paint a background. Glue the skin onto a painting surface using gloss acrylic gel.

Portraiture has been a popular style for many artists and audiences throughout the ages. For portrait painter Lea Bradovich, continuity between humanity and nature is a key concept, visible in her portrayals using fashion and headgear to create fanciful portraits. Inspired while looking at a photograph of a giant bee head, Bradovich integrated botany with Renaissance style portraiture in the painting shown opposite, adding irony, freshness and an element of surprise. Note the honeycombed collar, bee-head hat, and mouth located where a bee's mandibles would be in *Queen Bee's Regalia II* (page 23). According to Bradovich, "We humans seem to fashion everything we find into headgear. And headgear is symbolic."

Painted in the style of Italian Master Bronzino (Agnolo de Cosimo), *Queen Bee's Regalia II* follows his traditional, refined and aristocratic flavor. A "queen bee" in human society would be cool, aloof and alluring, and here, appropriately paired with Bronzino's painting style, it creates an interesting dialogue between old and new.

The Artist's Process

If an idea amuses Bradovich and makes her smile, she will investigate it further, even if some ideas seem goofy or silly at first. Bradovich starts by collecting reference materials including historic costumes, old masters portraits, fashion magazines and science photographs. These are maintained in boxes, files and on her computer so that she can leaf through for ideas, allowing for cross-fertilization.

Initial drawings give Bradovich a jumpstart, continuing by painting on panel with acrylic gouache, leaving room for accidental things to happen.

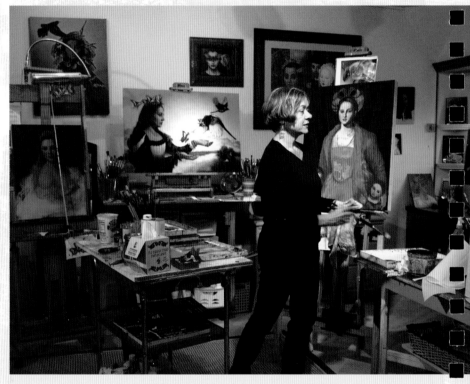

Dramatic studio lighting plays off multiple portraits in Lea Bradovich's studio.

On occasion she will work from models. Serendipity keeps the work changing, thus avoiding a paint-by-number appearance. Using washes, dry brush, and any technique that works for her at the time, she sometimes builds up areas with small overlapping brushstrokes.

Other Art in This Style

- Renaissance masters Agnolo Bronzino and his teacher Jacopo da Pontormo
- Portrait photographers Annie Leibovitz, Dorothea Lange and Cindy Sherman
- Psychological aspects and technical mastery of contemporary figurative realists Michael Grimaldi, Lucian Freud, Eric Fischl, Philip Pearlstein, Avigdor Arikha, John Currin, Alice Neel, Käthe Kollwitz, Chuck Close, Gerhard Richter and Bernardo Torrens
- Photographic portraits by Nan Goldin, Cindy Sherman and William Wegman
- Lifelike sculptures of Duane Hanson.

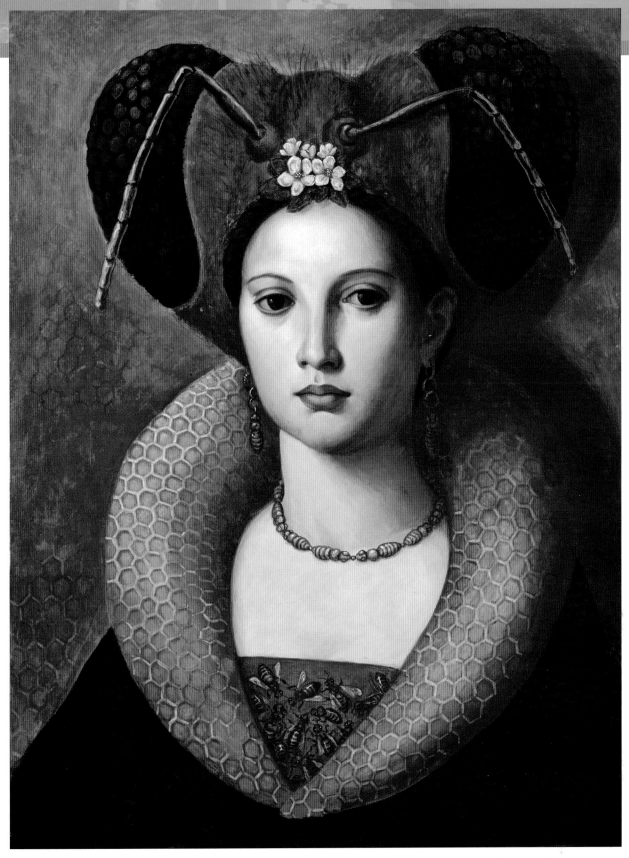

Lea Bradovich
Queen Bee's Regalia II
Acrylic gouache on panel
24" × 18" (61cm × 46cm)
Collection of Renee Goshin

More Variations

- Compare painting a portrait from life versus photographs by getting a friend or model to pose. Paint them from life in several sittings, then photograph them to work from the image as reference.

- Use your most available model—yourself—and paint a self-portrait using a mirror, photographs or memory. Paint self-portraits at intervals in your life to create a series.

- Research and interview to find out about the person you are painting. What do you like about this person? Translate these personality traits into the work through unusual cropping, varying color palettes, placement in unusual backgrounds, and adding costume and prop elements.

- Stage your own settings using costumes and props like Cindy Sherman's self-portrait series.

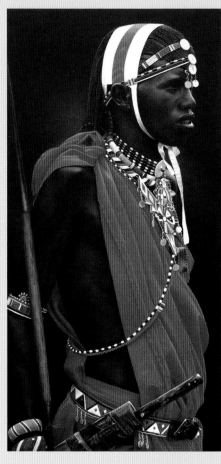

Variation 1: Add Personality With Clothing and Objects

Costume and personal objects add a hint of narrative, personality and culture.

Daniel Smith
Colors of Kenya—Warrior
Acrylic on panel
14" × 28" (36cm × 71cm)

Variation 2: Enhance Mood

A soft, muted limited palette, simplified background and unusual elongated format adds mood and a contemporary feel to this portrait.

Daniel Barkley
Petit nuage a l'horizon
Acrylic on canvas
54" × 76" (137cm × 193cm)

Preparing a preliminary detailed line drawing offers a jumpstart to any painting, especially when it's drawn directly on the painting surface. Starting with the flexibility of charcoal, where lines can be easily erased and changed, this technique changes the charcoal drawing into water-proof graphite, making it smudge-proof for subsequent overpainting.

Tip

If your drawing surface is too slick and the charcoal will not easily adhere, apply a thin amount of matte medium onto the surface, let dry, then continue drawing.

Materials

- **Drawing Materials:** Vine charcoal, soft graphite pencil, chamois or soft rag
- **Surface:** A primed surface

1. Create a Charcoal Drawing

A semi-slick surface is best, particularly a surface primed with acrylic gesso. Draw onto the primed surface with soft vine charcoal. Erase and rework as necessary, using your fingers, eraser, chamois, smudge sticks and rags. Keep working the drawing until it is exactly what you want. Here is a finished portrait underdrawing using vine charcoal.

3. Wipe off the Charcoal

Wipe away the vine charcoal using a chamois or a rag to reveal the graphite lines underneath. Graphite will not be affected by any subsequent overpainting with acrylic, producing an underdrawing ready for painting.

2. Retrace With Graphite

Using a graphite pencil, retrace the important lines with medium pressure directly over the vine charcoal lines.

Still life depicts subjects such as flowers, shells, inanimate objects, fruit and skulls—just about any object with the exception of people and animals. This style generally involves a grouping of objects, set off by a closely distanced background. Still life was popularized in the seventeenth century, and still holds fascination for us by implying humanity's symbolic presence, adding perspective on culture, lifestyles and attitudes of the times.

The Artist's Process

Traditional still life offers Sherry Loehr the opportunity to evoke a quiet and contemplative mood. For her, simplicity is essential. She chooses all of one type of fruit, for example, or clusters several items together to create one large shape. Loehr stages the objects in a classic still life format, then photographs them, leaving background areas open for interpretation. She uses photographs only to get an initial compositional sketch, then lets go of this reference to allow plenty of room for imagination. "I can't think of anything more boring than copying a photo because you know what it will be like and the best it can be is as good as the photo," states Loehr.

Loehr adds paint layers, continually working and reworking areas to expose varying underlayers. She loosely paints background areas using spontaneous patterns and textural areas in quiet tones. Her simplified backgrounds contrast with tightly detailed objects, keeping Loehr's work fresh and contemporary. Loehr was inspired early on by instructor Katherine Chang Liu (featured on page 114). Liu, an abstract painter, encouraged Loehr to find her own voice.

(featured on page 114)

TIPS from the Artist

Look beyond your normal vision for inspiration and explore a wide variety of work and resources that are not necessarily similar to your own style. Go beyond art museums and art books, and look at science museums, fashion, commercials, your house and local environment.

Loehr At Work in Her Studio
Loehr's "love-hate" relationship with acrylic comes from the struggle necessary to achieve controlled edges and blending, while enjoying freedom and playfulness in the loosely painted areas.

Other Art in This Style

- Seventeenth century painters from the Netherlands, especially Dutch flower painting and trompe l'oeil
- American modernists such as Raphaelle Peale and his group of early American still life artists
- American trompe l'oeil painters John Haberle, William Michael Harnett and John Frederick Peto
- Moody works of masters Francisco Goya, Gustave Courbet and Eugène Delacroix
- Contemporary artist Janet Fish

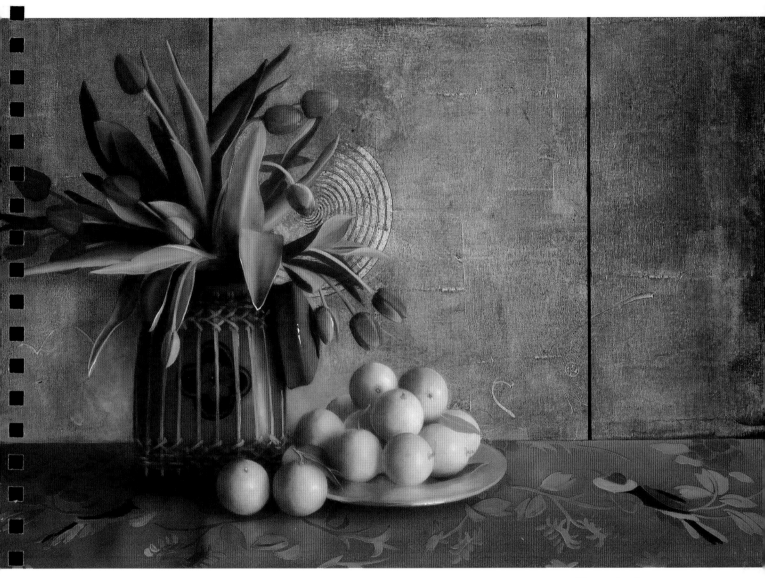

Sherry Loehr

Tulips and Oranges

Acrylic on board

24" × 36" (61cm × 91cm)

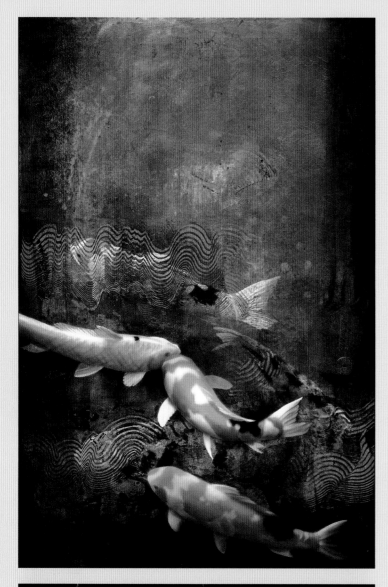

More Variations

- Change your painting formula. Make a list of all the habits and processes you use. Then make another list that contains their opposites. Break up your routine by trying one of the opposites. For instance, if you always start with a drawing or undersketch, switch to starting spontaneously with paint. If you always work from photographic references, try working without them. Vary your usual subject matter. Paint on different surfaces. Use a new medium.

- Change the balance of elements between the background and foreground. Enlarge objects while minimizing the background, or expand the background and minimize the objects.

Variation 1: Using Living Subject Matter

Instead of using the traditional inanimate objects for a still life, Loehr paints live swimming fish. Visible here is Loehr's trademark style contrasting realistically detailed forms with looser experimental backgrounds.

Sherry Loehr
Koi Chi
Acrylic on board
36" × 24" (91cm × 61cm)

Variation 2: Add Decorative Flourishes

The addition of decorative flourishes and geometric patterns turns this still life into a delightful fantasy.

Mary L. Parkes
Angelic Apples
Acrylic and oil on linen
30" × 40" (76cm × 102cm)

Loehr loves red; it plays a key role in her color palette and composition. Loehr enjoys employing its full range from a cool magenta-purple red to a warm orangey red. Here are two ways to keep reds looking their brightest with acrylic paint.

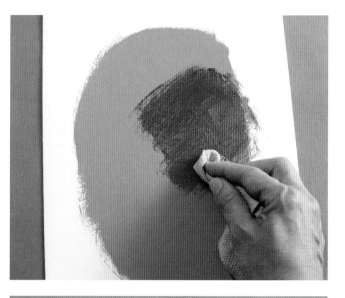

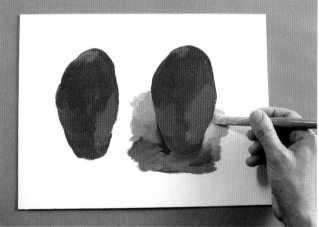

Overlay a Glaze

Squeeze a warm bright red such as Cadmium Red and a cool bright red like Quinacridone Magenta onto your palette. Paint out an area of red by using either the Cadmium Red straight out of the tube or mix a small amount of white with Quinacridone Magenta (use about 5 percent white if you're using an opaque white like Titanium White. With a transparent white like Zinc White, use 20 percent). This will bring out the color intensity of the modern color. Do not add white to the mineral color Cadmium Red or it will lose its intensity and get chalky. Overpaint the red with a thin glaze made from a 1:1 mixture of untinted Quinacridone Magenta and gloss acrylic medium. Apply thinly using a soft flat brush or rag.

Pair the Red With a Complement

To make the red appear even brighter, paint a contrasting color next to it, such as a muted red, a green (which is red's complement) or a dark color. A muted red can be mixed using red, a touch of black (or green) and some white. Here a muted green is applied in varying values next to red to make it appear brighter.

Tip

Avoid buying paint from manufacturers that add white to their modern pigmented colors like Quinacridones and Phthalos. Start with an unadulterated paint (one that comes out dark from the tube) to get good color mixing control.

The ideas above can be performed with the other two primaries, yellow and blue. For yellow, use Hansa Yellow Medium, Cadmium Yellow Medium or Hansa Yellow Light. For blue, use Ultramarine Blue or Phthalo Blue (Green Shade). Phthalo Blue is the only color in this grouping of yellows and blues that would intensify with white. For the other colors, use them straight out of the tube for the brightest effect.

Landscape painting depicts natural scenery such as mountains, trees and rivers, and still holds a powerful influence and inspiration for artists and viewers.

Dennis Culver, living in the southwestern United States, enjoys the local vistas, especially midday, when colors are quiet with no shadows. Not wanting his paintings to merely re-create nature, Culver always starts with a vision from his imagination. By painting directly outdoors and avoiding any photographic references, he distances himself from photographic reality. In the painting shown on page 31, Culver has added subtle geometry infused with triangles and native symbols, most visible in the foreground rocks, encouraging the viewer to move from scenery toward ideas.

The Artist's Process

In *Arroyo Logic*, Culver started with several earth tones on a toothbrush, spritzing a variety of dots along the bottom half of the painting. He then drew lines connecting the dots to create irregular geometric patterns which formed the initial inspiration and unusual composition in the foreground. Much of Culver's starting processes come from playing with materials. This play keeps his work spontaneous and varied. He prefers acrylic for its nontoxic, fast drying qualities, and vast potential in attaining varied sheens and surface treatments. Additionally, he enjoys the freedom of layering acrylic with no rules, as opposed to oil with its "fat over lean" restrictions.

TIPS
from the Artist

Familiarize yourself with all the traditional mediums from watercolor to egg tempera. Experiment. Don't leave out acrylic because it's less traditional—you'll be missing a whole lot of fun and surprising results.

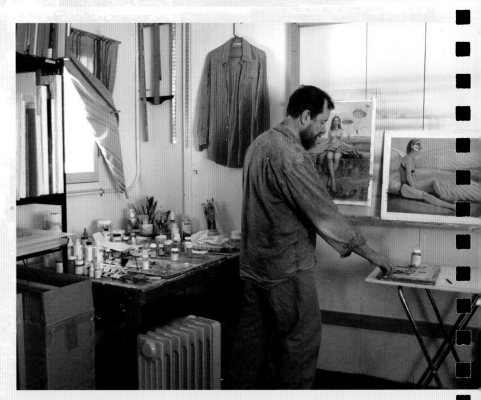

Dennis Culver at Work in His Studio
Culver's work isn't about being realistic, and always contains something surprising.

Other Art in This Style

- Minimized detail and grand panoramas of imaginary landscapes in early Chinese landscape paintings
- Large scale and vast epic views of Frederic Edwin Church, Albert Bierstadt and other Hudson River School artists
- Idealized landscapes of the Italian Renaissance painters like Titian

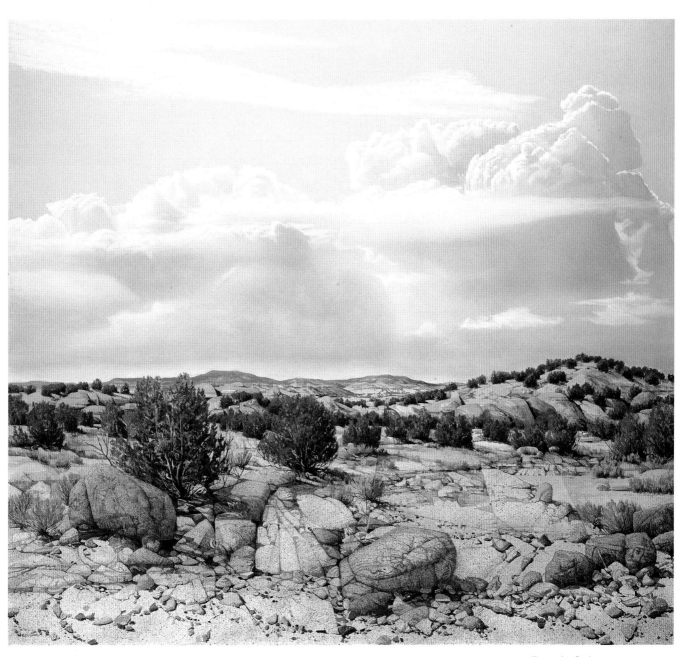

Dennis Culver
Arroyo Logic
Acrylic on canvas
56" × 62" (142cm × 157cm)

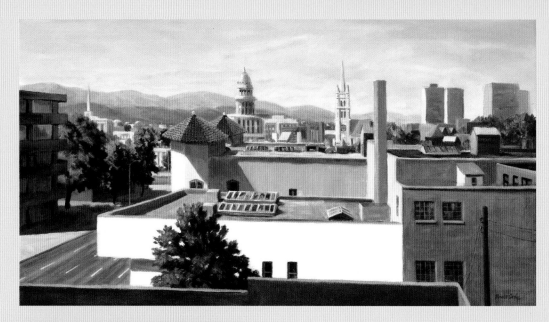

Variation 1: Urban Landscapes

For Bruce Cody, art is about people and architecture, and can be seen as a social symbol. Cody uses inanimate elements such as buildings, cars, signage and telephone transmission poles to transform the objects into layers of space, atmosphere and time of day.

Bruce Cody
Capitol City Sunlight
Acrylic on canvas
16" × 30" (41cm × 76cm)

Variation 2: Close Cropping

Here Garrett's use of close framing strengthens the composition, creating an intimate and unusual view.

Phil Garrett
Jones Gap/Red Rocks
Acrylic on linen
42" × 60" (102cm × 152cm)
Collection of Palmetto Bank,
Greenville, SC

More Variations

- Use multiple references to create a new scene. One photograph can be used for its color palette, another for composition, and other photographs that contain natural forms such as trees, clouds, animals, etc. for added elements. Combine a sky from one photograph with ground from another.

- Paint the same landscape three ways: Outdoors, from a photograph and from memory, then compare the results. Paint the same scene several ways in varying weather, or light during different times of day (see Claude Monet's *Haystacks* paintings).

- Paint a landscape using unexpected colors, such as green for the sky and blue for the ground.

Smaller images or sketches (often called maquettes) make great starts for large paintings. This is especially helpful for landscapes. When traveling outdoors, it's easy and convenient to create many quick, small, on-the-spot pieces. Gridding provides a quick way to enlarge these later in the studio. Traditional grids using charcoal or graphite lines are difficult to remove later. This gridding technique, however, leaves behind no marks.

Tip

If your painting surface has no sides, place push pins close along the edges. For large-scale works, use an additional color for main gridding lines to help navigate while transferring.

Materials

- **Paints:** Any acrylic paints
- **Surface:** Any support (optimally with sides)
- **Painting Tools:** A brush
- **Other:** A small image you want to transfer and enlarge, cotton twine, pushpins, hammer, pencil, ruler, two waterproof markers differing in color, mylar or other clear plastic, scissors, tape, a small piece of cardboard, water

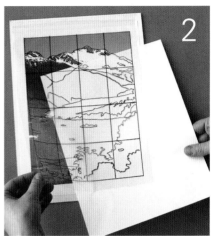
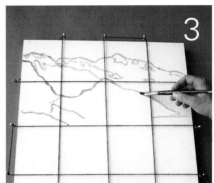
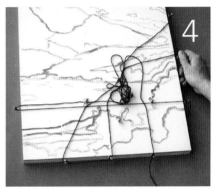

1. Prepare the Maquette
Begin with a small image you want to transfer to a larger scale. Protect it by taping it onto a piece of cardboard and covering it with a taped piece of clear mylar or plastic.

2. Grid the Image to be Transferred
Using a waterproof marker, draw onto the plastic by tracing only essential lines and shapes. Keep detail to a minimum, focusing on large compositional lines (pictured in red). Change marker color for the grid lines (here using black), and create a checkerboard grid. Slip white paper between the plastic and the original drawing to isolate the lines and minimize unnecessary detail.

3. Grid the Painting Surface With String
Using a painting surface with sides, hammer pushpins at all points along the sides angled slightly upward. Take one end of a

ball of string (the same color as the grid lines) and knot it onto one of the pushpins closest to a corner. Wind the string along the pushpins, creating all the vertical and horizontal lines, winding a bit around each pushpin as you go. Secure the string to the last pushpin with a knot. The string will be slightly raised from the surface if pushpins are angled correctly. Add water to a light colored paint and brush apply to re-create the same compositional lines from the maquette onto the painting surface. Focus on one grid square at a time. Allow the brush to go under the string, continuing lines that travel between grid squares. Instead of erasing to correct a wrong line, try changing color.

4. Remove Pins and String
When all the compositional lines are painted, pull out the pushpins along with the string grid. The end result is a transferred image with no visible grid remaining.

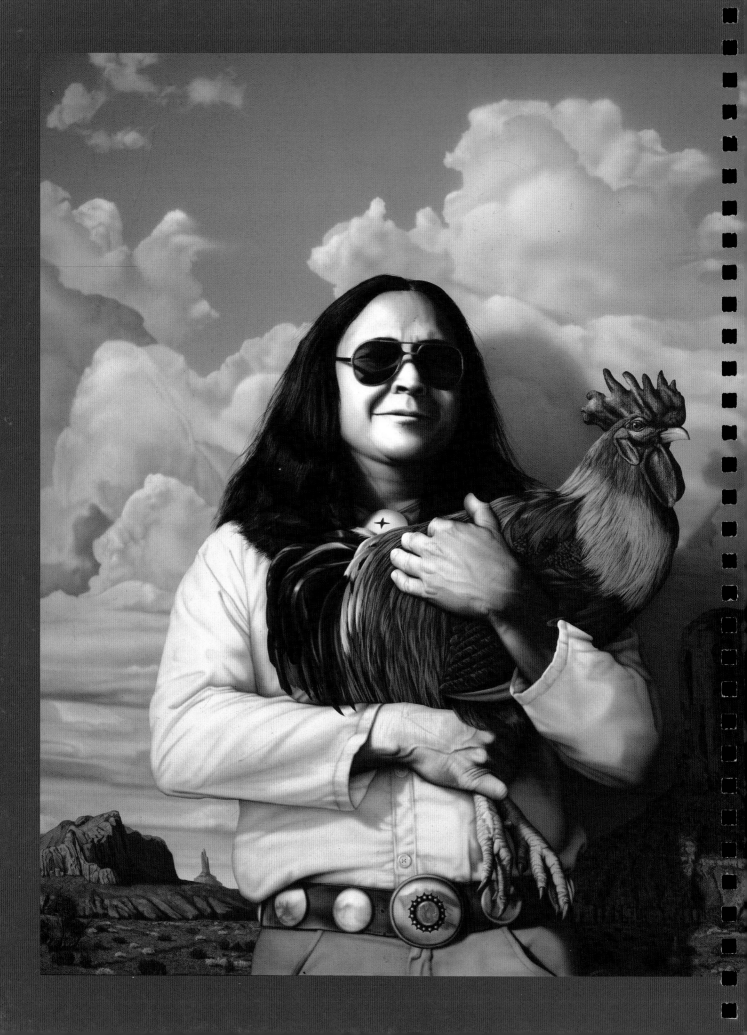

Section **2**

ABSTRACTING THE WINDOW

An abstract painting engages the viewer in a different way than realism. Abstraction minimizes detail and recognizable imagery, moving the emphasis toward aesthetic elements such as line, shape, perspective, form, texture and space. This section explores styles that still use some realistic principles such as approaching the canvas like a viewing "window," and maintaining a sense of background, foreground and fixed perspective. Imagery here combines both realistic and abstract elements directing the eye toward more subtle aesthetics, often resulting in an unexpected twist.

Tom Palmore
Phil With His Favorite Chicken
Acrylic on canvas
72" × 60" (183cm × 152cm)

As humans, we have a natural and immediate response to body imagery in art, and its use can ground a work in space and create a connection with viewers.

Figures have always been a focus in Jylian Gustlin's work. She creates characters and sets them in moody and unfamiliar landscapes. By reducing detail in the figure and facial features, Gustlin also obscures the figure's gender and race. In this way, she hopes to move the focus of her work away from particular individuals and toward the idea of being human. Most communication, Gustlin muses, comes from body language or gesture, which carry the meaning of her work.

The Artist's Process

Gustlin's fascination with and study of science and math, especially theories on the Fibonacci sequence, are visible in the way she divides her backgrounds and proportions the body. Metaphysical ideas, including stillness in motion, also play a key role in her work.

Gustlin starts with a wood panel, gesso and many layers of plaster and creates an etched relief using chisels. She continues to build multiple layers with a variety of materials: oil, acrylic, charcoal, wax, gold leaf, pastel and graphite. In the painting process, she makes as many mistakes as she can for as long as she can until the painting is finished. She eventually adds a final thin coat of resin to intensify the colors and emphasize texture. A creative block is rare for her, as she leaves her process open-ended, never deciding where she's going—and, states Gustlin, "You can't get lost if you have no

destination." When frustrated, she likes to load a brush with paint and throw it at a surface until something comes up. Inspirational artists for Gustlin include Nathan Oliveira, Richard Diebenkorn and the brooding, haunting qualities of Odd Nerdrum's portraits.

TIPS from the Artist

Make art as much as possible to find your voice. Play as much as possible; don't be too serious. Combine everything you learn like a soup—play, relax and paint. Mistakes are a way to bring the image into focus and to find your way to the finish. If it doesn't work, it's not finished.

An expert in computer science, Gustlin finds parallel painting techniques to those found in Photoshop's layering tool. She even created her own computerized software which takes her scanned images of drawings, textures and photos and randomly combines them to make her abundant reference material.

Other Art in This Style

Inventive combinations of figure and abstraction, including the Bay Area Figurative Movement, Francis Bacon, Aristide Maillol, Willem de Kooning's *Woman* series, Philip Guston and Jean Dubuffet.

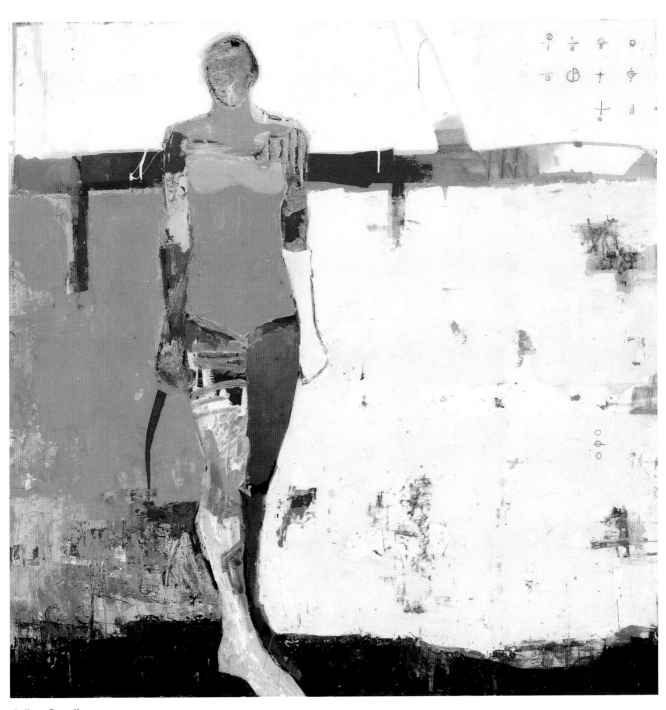

Jylian Gustlin
Bivium 18
Acrylic and mixed media (plaster, oil stick, pencil, resin) on panel
48" × 48" (122cm × 122cm)
Corporate collection

Variation 1: Isolation

Emphasize or isolate parts of the body. Here an open-mouthed portrait echoes the open mouth shape silhouetting or framing it.

Joey Fauerso
Mouth to Mouth (1)
Watercolor and acrylic on paper
48" × 46" (122cm × 117cm)
Private collection

More Variations

- Draw or photograph figures in various positions. Cut them out and place them on a variety of backgrounds—solid or multicolored, smooth or textural, patterned or simple, abstract or realistic. Keep playing until ideas emerge that you like.

- Trace outlines of figures. Working only with these generalized lines, change, expand, eliminate and add lines to transform the figure into something else.

Variation 2: Transformation

Allow figural shapes to transform and transmute. Starting with a charcoal drawing of textures, and combining with acrylic gesso, this playful investigation of materials formed into a central figure while creating a range of grays.

Dennis Culver
Politician
Charcoal and acrylic on paper
44" × 30" (112cm × 76cm)

Gustlin's work features seductive surfaces employing a variety of textures. Her technique uses multiple layers of plaster, chiseled to create etched relief lines and contrasting texture. Here is a variation using acrylic molding paste.

Materials

- **Surface:** A rigid and sturdy primed painting surface such as gessoed wood or panel
- **Painting Tools:** A large plaster knife or other applicator; an array of texture tools such as combs, rakes, sticks and fingers
- **Other:** Acrylic molding paste

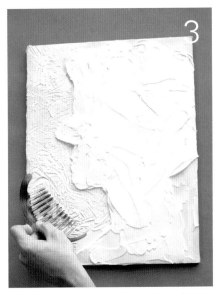

1. Etch an Outline Into Wet Paste

Using a primed rigid support, generously apply acrylic molding paste all over the panel using a palette knife or wide plaster knife and smooth it as best as you can. Keep the layer about ¼-inch (6mm) thick or more. Using a tool that will easily create a line, such as a stick or the tip of the painting knife, draw the outline of a central form into the wet paste.

2. Create Varying Levels

The painting now has two distinct areas created from the etched lines in the previous step: inside the form and its background. Select one of the areas to be raised up higher than the other. Apply another layer of paste in that area in any level you prefer. The varying heights help to emphasize form and background. Continue to the next step while the paste is still wet.

3. Contrast Textures

Select one of the areas to add a texture. If the paste has started to dry in that area, reapply a fresh layer of paste. Apply combs and other tools to the wet paste, scrape and draw to get a variety of lines and patterns. Allowing one area untouched to remain smooth contrasts nicely with the textural area just created. Alternatively, in the smooth area, create a different texture by adding more paste, using different tools, or embedding beads or other small objects. Allow the surface to fully dry before applying paint.

Tip

Try adding color to the paste. Use different colored layers, sanding back to reveal the various colors. Sanding is also a good way to reduce texture. If sanding, always use waterproof sandpaper and water to eliminate exposure to toxic dust.

Our eyes absorb an infinite amount of detail as we perceive reality. A reductive style reveals what the artist finds essential. Distillating unnecessary detail places the focus on bold shapes and the artist's personal vision.

Frank Webster portrays postindustrial landscapes—the modern city—combining minimalism and realism and revealing the connection between nature and technology. His editing process, essential to a reductive style, is driven by intuition and taste used for clarity and impact. Webster succeeds in carrying a hint of narrative with a clean elegance and a feel of minimal essentials.

The Artist's Process

Inspiration comes from reading science fiction books, including the dystopian works of J.G. Ballard, with a great sense "of the not too distant future." Trips to shoot reference photos, architectural research, even finding great compositions in films with epic cinematography, all add to his collective resources. Webster sketches and works digitally to get to the essence of the image. Multiple glazing layers add intensity to his simplified areas. Some of Webster's favorite artists include Tom Morandi, Dan Graham, Robert Smithson and photographer Robert Adams.

Other Art in This Style

- Reductive process: Compare Piet Mondrian's well-known grid abstractions with his early landscapes.
- Reductive urban and industrial: Charles Sheeler and Ralston Crawford.
- Contemporary and modern artists: Ed Ruscha, Andy Warhol, Roy Lichtenstein, Philip Guston, Jacob Lawrence, John Marin, Wolf Kahn, David True and Milton Avery

◔ **TIPS** from the Artist
...
An editing process is idiosyncratic.

Webster noticed postindustrial changes growing up in the midwestern United States. Charles Sheeler and his modernist contemporaries painted romanticized, optimistic versions of modernity and technology. Now, with hindsight and contemporary eyes, Webster adds a new outlook on the subject, with an intention toward subtlety.

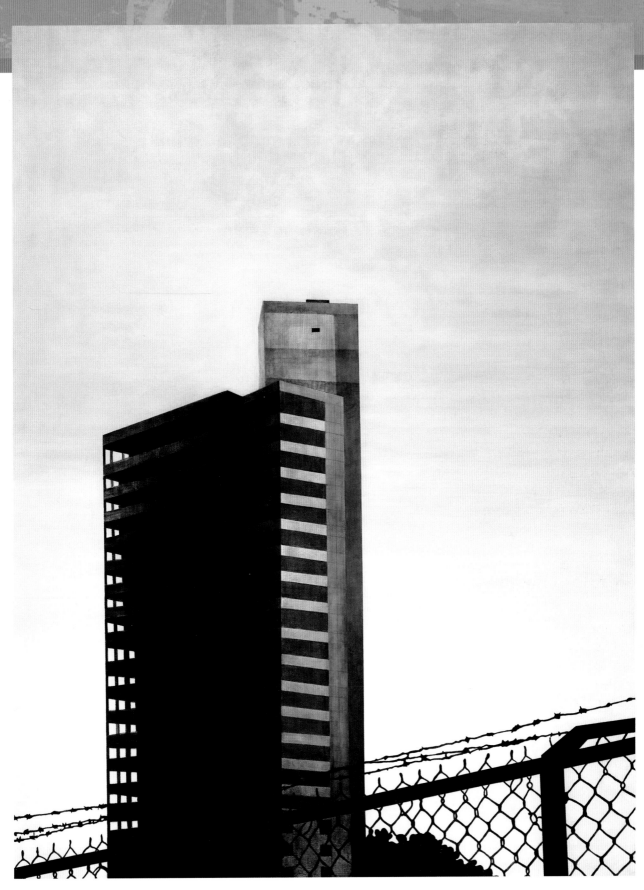

Frank Webster
High Rise
Acrylic on canvas
86" × 65" (218cm × 165cm)

More Variations

- Take photographs of places, people or events you like. Paint over areas with opaque paint to eliminate detail. See how much you can eliminate and still portray what you think is important.

- Transform color images to black and white using photography and/or computers to see them differently.

- Play with colored cutout shapes, arranging and collaging onto larger colored paper, as an exercise in working with bold areas and no detail.

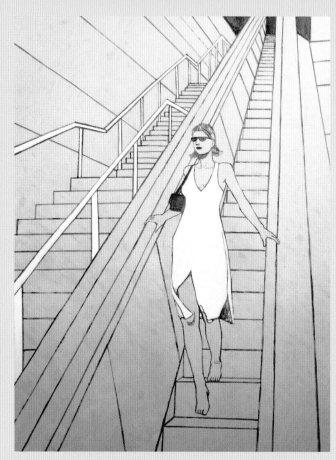

Variation 1: Contrast Flat Space With Perspective

Simplified forms combine with linear perspective to create an interesting visual tension between flat and deep space.

James Strombotne
Escalator Girl
Acrylic on canvas
48" × 60" (122cm × 152cm)
Courtesy of Handsel Gallery, Santa Fe, NM

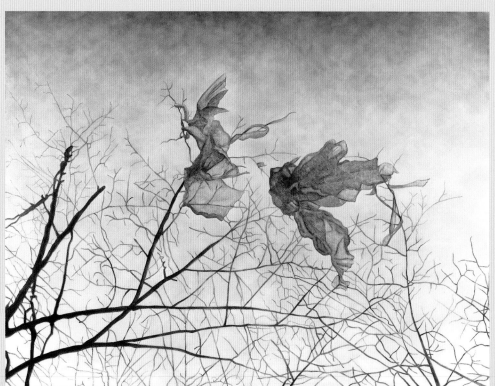

Variation 2: Seek a Different Point of View

Singling out an atypical view creates an immediate attraction in this piece.

Frank Webster
Plastic Bags
Acrylic on canvas
60" × 80" (152cm × 203cm)

ELEGANT CURVED EDGES

A reductive style often makes use of simplified lines and edges. Dave Yust, whose work is shown on page 94, uses this method to get refined hard edges with curved designs.

For this technique, use masking tape that's ¼-inch (6mm) because it curves easily with minimal crimping.

Materials

- **Paints:** Any acrylic paint colors
- **Surface:** Any primed painting surface
- **Painting Tools:** Any soft painting brush
- **Other:** ¼-inch (6mm) masking tape, any clear or non-colored acrylic medium or gel (glossy or matte), optional hair blow-dryer to quicken drying time

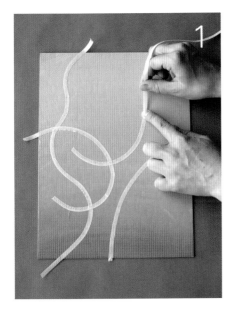

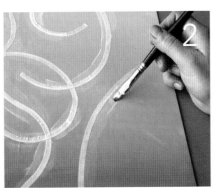

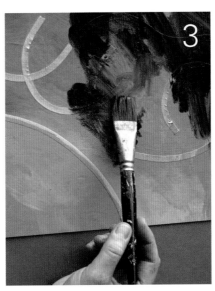

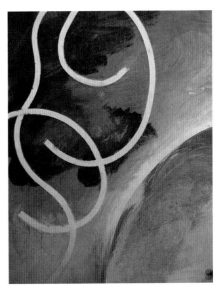

Finished Example

1. Tape the Area

Using a surface that is primed and/or pre-painted with a background, plan where you wish to have hard edge painted lines or forms. Apply ¼-inch (6mm)-thick masking tape in a design or bordering a shape. Pull the tape firmly with one hand while pressing it into place with the other to keep the tape lying as smooth and flat as possible. Press along the edges to secure. Here a pre-painted background using a gradation of green and pink will remain visible in the final outcome only where tape is applied.

2. Seal the Tape Edge

Reduce paint seepage under the taped edges by applying a clear non-colored acrylic medium or gel with a brush along the edge of the tape. Quickly dry with a hair blow-dryer for a minute and continue to the next step.

3. Apply Paint Color

Apply paint color to either or both sides of the tape depending on your preferences, feeling free to paint over the tape when needed. Immediately remove the tape after painting. If the tape is left on the surface while the paint dries for a prolonged period, it may be difficult to remove later without pulling up the paint along with it. To reduce problems with tape removal, roll or peel it back onto itself rather than pulling upward.

Since a painting surface is naturally flat, one challenge for artists is to construct the illusion of space. In the twentieth century, a new trend emerged, rejecting the deep illusionistic space from the Renaissance. Instead, the emphasis was on flat space. The challenge changed to maintaining the integrity of a painting's image when flat to avoid looking like wallpaper. Detail and complexity still inform the work, but emphasis is placed on the painted surface and perspective is minimized. A master of this style, James Strombotne's sophisticated works employ deceivingly simplified areas and forms, clearly visible in his painting *Circus Elephant* shown on page 45.

The Artist's Process

Strombotne makes it a point to draw every day, and believes this is an essential tool to keep his work fresh, while paint quality and personal experience are also key. Strombotne says, "The craft of painting what you see is as rich and compelling as the use of the paint." Painting is more than just an illustration telling a story. Using a minimal palette helps Strombotne add simplicity with the appearance of effortlessness. He doesn't want his pieces to look like a lot of work, but instead to carry a sense of freedom and naturalness. Too reductive is boring, so the challenge for him is letting it be reductive but still compelling. After three to six layers of paint, he draws over the layers with charcoal, then paints over the drawing, sometimes covering the lines up entirely. An acrylic painter for over thirty years, he favors this medium over oil, because it maintains its luminosity and the feeling of naturalness.

He finds Georgia O'Keeffe's watercolors fresh, interesting and accomplished. He also likes artists such as Rembrandt, Francisco Goya, Henri Matisse and Pierre Bonnard.

Strombotne notes that artists in general seem to gravitate towards more reductive and simplified work as they get older. They are more apt to "cut to the chase," as they mature.

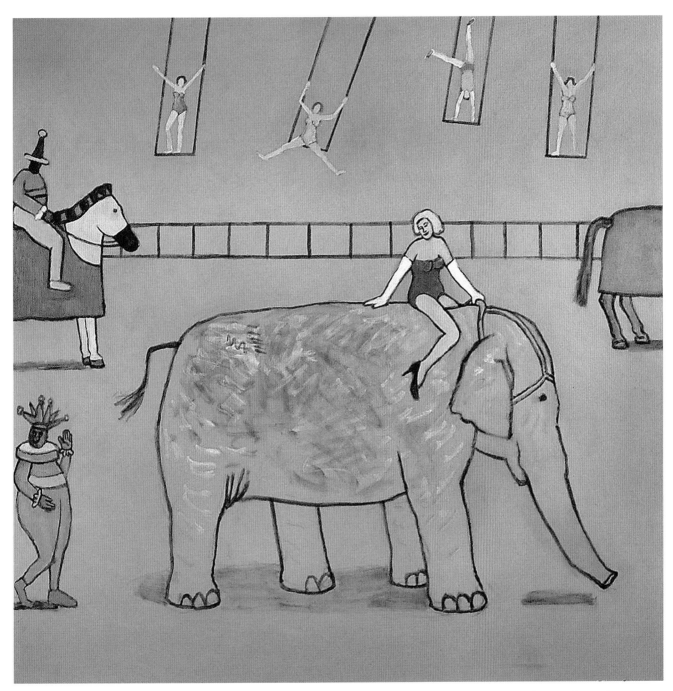

James Strombotne
Circus Elephant
Acrylic on canvas
40" × 36" (102cm × 91cm)
Courtesy of Handsel Gallery,
Santa Fe, NM

Other Art in This Style

- Pop artist Tom Wesselmann, and the comic book style of Roy Lichtenstein
- Comic book artists
- Strong patterns and simplified flat space of Henri Matisse, Milton Avery and Joan Miró
- A wide range of flat space imagery from American modernists like Marsden Hartley and Stuart Davis. Also the work of Fernand Léger and Anna (Grandma) Moses
- Great masters from the Florentine School and Byzantine period

VARIATIONS ON FLAT SPACE

Variation 1: Contrast Detail with Space

The contrast between exact detail with the shallow space adds a compelling quality to this still life.

Barbara Moody
Chinois
Acrylic on canvas
30" × 40" (76cm × 102cm)
Private collection

More Variations

- Any techniques that bring attention to the actual surface of the painting, such as texture or sheen, will create an interesting visual tension when combined with the illusion of spatial depth. Experiment with gels and pastes to create texture before or after applying a painted image.

- Reduce or eliminate perspective techniques. Take out horizon lines or other lines that angle into the picture. Increase the use of drawn lines and repeated geometric patterns. Play with the idea of spatial depth by enlarging the size of forms that appear far back, and reducing the size of objects and forms that are closer (nearer to the bottom of the picture).

- Paint a realistic scene minimizing the color shifts or gradations that are normally used to create the illusion of light and volume. Instead, paint some areas using flat, evenly applied color.

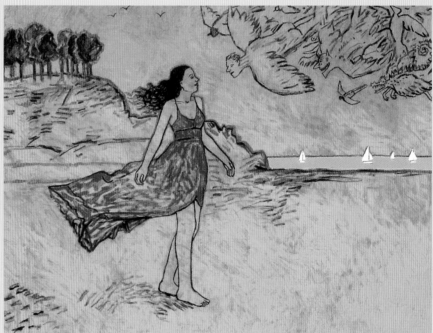

Variation 2: Reduce Detail and Minimize Color

Reducing detail and minimizing the color palette places an emphasis on the artist's intent.

James Strombotne
Summer
Acrylic on canvas
56" × 68" (142cm × 173cm)
Courtesy of Handsel Gallery, Santa Fe, NM

EDGE CONSCIOUSNESS

Paintings using a flat or shallow space still depend on some illusion of depth within the image. Overlapping forms give the illusion of spatial depth, created through the use of edge relationships. A variety of edges from hard to soft, as well as distinct overlapping adds space and a clean look to the work.

Tip

Rework and refine edges in a painting with a small brush and work with the colors both inside the forms as well as outside or background.

Undefined Edges Create Ambiguous Space

Here a variety of forms are painted on a peach background. The edges of these forms are all somewhat ambiguous—they are neither hard nor soft and do not clearly indicate whether one form is in front or in back of another. Notice how the space feels and compare this to the next image.

Define Edges to Enhance Space

A wider variety of edges are created by intentionally making some edges cleaner, crisper and harder while others are softened and blended. Now it's easier to tell which form is in front of which, and the space feels more expansive.

Eliminate Edge "Kissing"

This image illustrates a common problem of shape "kissing." On the left there are three shapes all sharing common edges. This makes it difficult to tell which form is in front of another. On the right the same set of three shapes overlap one another, thereby increasing the illusion of space.

Romanticism originated toward the end of the eighteenth century in Europe, using images of untamed nature and eliciting emotions such as loneliness and a dreamlike state of mind. The use of soft edges, soft focus, hazy atmospheric qualities and muted palettes add to the surreal beauty often found in these works. Artists can use these techniques in conjunction with contemporary subject matter to evoke a nostalgic or emotional response. This is visible in the work of McCreery Jordan, whose images take on mysterious and haunting tones. In *Companeros* (page 49), a horse and raven are engaged in some form of secret communication, the ring in the bird's beak underscoring the romantic flavor.

The Artist's Process

Jordan's inspiration is time. Layers and veiling of time and history are echoed in her surface "patinas," which she creates using antiquing, sanding and texturing, then repeating these processes in many layers. Sometimes she'll find and use old doors with their own history. If an object looks too new, she'll sand and stain it, texturizing and antiquing the surface for a few days while allowing the image to emerge. Collage and the use of photographic images are integral to her work and process. Jordan stays connected with her content on a deep emotional level, encouraging this to come through in the finished work.

Jordan finds inspiration in the work of Joseph Campbell, the super-realistic still lifes of William Harnett and Jean-Baptiste-Siméon Chardin; the loose painting style and philosophy of contemporary artist Richard Schmid, and the textural imagery of Randall Lagro.

TIPS
from the Artist

The ability to work from your subconscious will allow your vision to come through. This requires many years to develop the necessary skills and tools: including drawing, mistakes, lessons, workshops and miles of canvas.

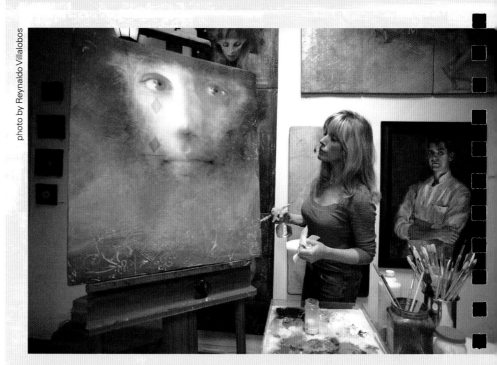

photo by Reynaldo Villalobos

McCreery Jordan in her studio/gallery space with new work. Jordan uses acrylic for its fast drying capabilities, which allows multiple glaze layers, and the ability to work thickly without cracking.

Other Art in This Style

- Emotional dreamlike imagery of Surrealists such as André Breton, Marc Chagall, Salvador Dali, René Magritte and Dorothea Tanning
- Moody work and color palettes of Paul Gauguin and Albert Pinkham Ryder
- Emotional content of Expressionists such as Edvard Munch
- Masters of Romanticism such as Joseph Mallord William Turner and Caspar David Friedrich
- John Constable's romantic interpretations of the English landscape
- Frida Kahlo, Emil Nolde

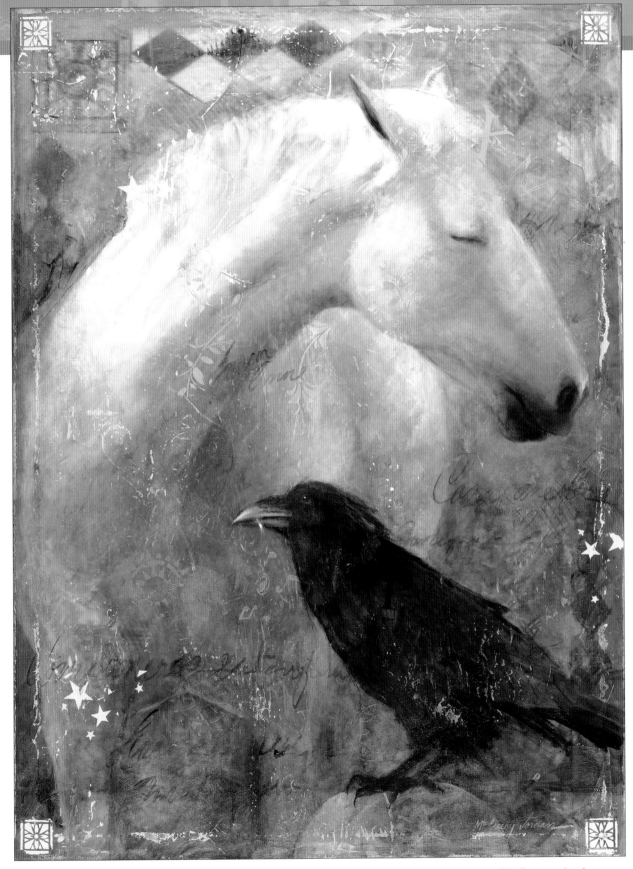

McCreery Jordan
Companeros
Acrylic on wood
48" × 36" (122cm × 91cm)

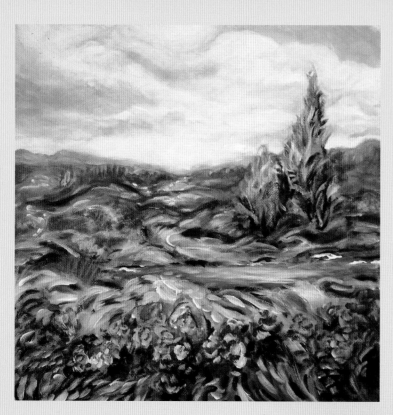

Variation 1: Soft Colors and Harmonious Flow

Romantic soft colors are used here along with a soothing directional flow moving toward a distant dreamy horizon.

Renée Phillips
Field of Dreams
Acrylic and oil on canvas with powdered pigments
12" × 12" (30cm × 30cm)

More Variations

- Make a list of things (colors, images, stories, events, adjectives) you find romantic, emotional or beautiful. Select a few of these to assemble together in one image.
- Mix a palette of colors that feels romantic to you, and use this to create a painting.
- Make a series of images you find romantic, each using a different context or subject matter including portrait, landscape, still life and abstraction.

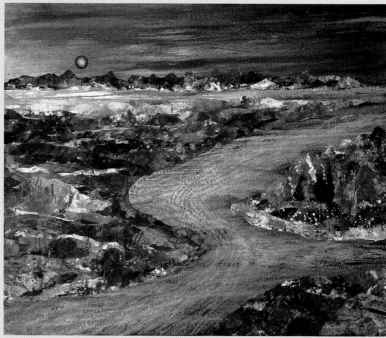

Variation 2: Limited Palette

Using a limited color palette with muted tones, Swartz infuses a spiritual and mysterious quality to this moonlit scene.

Beth Ames Swartz
The Thirteenth Moon: Only the Mindless Waters Remain
Acrylic and mixed media on canvas
60" × 72" (152cm × 183cm)

GLAZED EDGE ENHANCEMENT

This technique of vignette glazing can be used to add a romantic or mysterious feeling to a painting. By staining and darkening the outside edges of an image, the space feels more intimate. It can also add a feeling of containment in areas where the image appears to spill out of its frame.

Avoid extending the glaze color too far beyond the edge into the image or it can become distracting.

Materials

- **Paints:** Any acrylic paint (suggested colors: black, and a variety of earth tones in brown, green, rust and ochre)
- **Surface:** Any painting close to finish
- **Painting Tools:** Lint-free rag and/or painting brushes; color mixing palette
- **Other:** A slow drying clear acrylic medium in gloss or matte

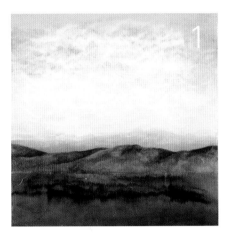

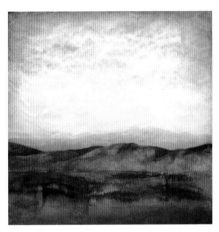

1. Select a Painting

Select a painting close to completion that will benefit by adding a romantic mood or more spatial containment. This painting's sky area feels too expansive in comparison to the dark and moodily painted ground. By selectively applying the vignette glazing technique in only the top sky area, the top and bottom halves will be more integrated, the whole image will feel more intimate and contained, and its romantic mood will be enhanced.

2. Make a Dirty Mix Glaze

Place several earth tone colors along with slow drying acrylic medium separately on a palette. Use at least four or five distinctly different color choices (pictured here are Sap Green, Burnt Sienna, Payne's Gray, Raw Umber and Carbon Black).

Dip a brush or rag into the medium, picking up about ¼ teaspoon of it, then directly dip into a small amount of paint color. Both medium and paint will be on your rag or brush simultaneously but not mixed together, which is called a dirty mix glaze.

3. Glaze Along the Edges

Apply this dirty mix along a portion of the outside edge using small circular motions. Keep working in a small area while the paint is still wet. Switch to a clean brush or dry rag to remove some of the excess glaze so the color subtly blends into the image. Repeat with more glaze and keep cleaning the brush or use a new dry rag in areas as needed. As you finish one area, move along the same edge using different combinations of color every 1 (25mm) to 2 (51mm) inches. Avoid using the same color for too long or applying it opaquely. Instead, use a variety of color and transparency to subtly enhance the image.

Finished Example

Compare this to the original image in step 1. Here, the colored edging in the upper half creates a cozy feel to the sky and enhances its mood.

51

Emphasizing aesthetic elements such as line, shape, proportions, color perspective, texture and space bring individuality and personality to a painting. Martha Kennedy defines her work as "bold compositions in mouth-watering color," and, sure enough, her color is juicy enough to taste. By exaggerating color, Kennedy enables the viewer to better respond with emotion. Kennedy wants her paintings to give people pleasure, to enable them to escape into another world. "Colors help you feel better, like sharing a smile," she says. Kennedy strives for simplicity. When elements are simplified, exaggeration can then come into play to enhance those aesthetic elements the artist prefers, such as color.

The Artist's Process

To get bold areas of exaggerated color, Kennedy works from photographs to assist in simplifying compositional areas. However, her color selections come from her imagination. She chooses colors that play against each other to pop, push, pull and create space. Once she's applied color to an area, she alters it, going lighter to darker, warmer to cooler, or brighter to duller as she creates volume.

Oil paint's slow drying properties allow for subtle blending that creates soft shifts in color, making oil Kennedy's primary medium. To replicate this effect, Kennedy has been experimenting with the new slow drying, or extended, acrylics. She has found ways to further extend her working time by using mediums, gels and thinners to resoften dried areas. The reworked surface creates a different type of texture, adding a new quality that she finds desirable and interesting.

Other Art in This Style

- Exaggeration/simplification of Fernand Léger, Milton Avery, Georgia O'Keeffe, Ed Mell, Amedeo Modigliani and Fernando Botero
- The bold color of Vincent Van Gogh

TIPS
from the Artist

Temporarily switching mediums (i.e., from oil to acrylic) can add a new twist to your work and process. Stick to one medium long enough, though, to go deeper into an idea. Avoid being seduced or distracted by switching mediums too often. For some artists, however, switching to a new medium can add a sense of play, experimentation and new inspiration.

Kennedy tapes reference images to the top of her easel while she works. References include an original composition sketch and ink-jet prints of her photographs. Paints and painting tools are located on easy-to-reach dollies. Natural light from windows and skylights are a boost for color decisions.

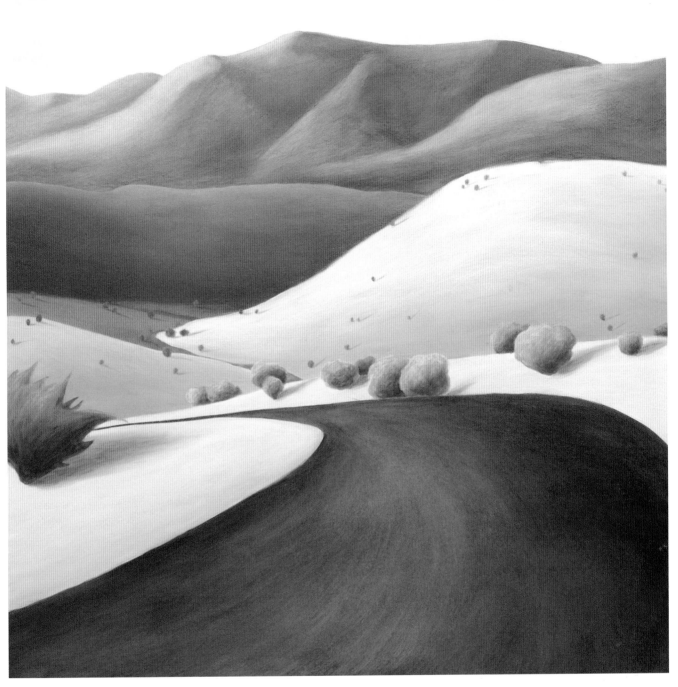

Martha Kennedy
Road Through Golden Hills
Acrylic on panel
16" x 16" (41cm x 41cm)
Collection of Debra and Chuck Blitzer,
Las Vegas, NV

VARIATIONS OF EXAGGERATION

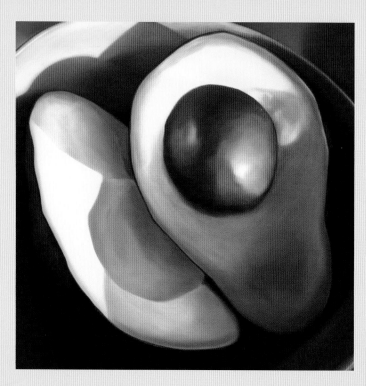

Variation 1: Enlarge and Zoom In

Here Kennedy changes her subject matter from land-scape to still life. Simplicity is achieved by selecting and enlarging one object, close cropping and keeping the background minimal. The large, simplified shapes are then painted with exaggerated color.

Martha Kennedy
Avocado on Orange
Acrylic on panel
24" x 24" (61cm x 61cm)

More Variations

- Try temporarily switching to a medium you haven't used before, such as pastel, watercolor, oil or gouache, and see how this changes your work.

- Create a few paintings with the same image, but in varying sizes, going from very small to very large to compare the impact.

- Create a painting from your head that eliminates all recognizable imagery, perhaps using geometric shapes and other nonrealistic forms, and modulate each color shape to give it volume.

Variation 2: Exaggerate Brushwork

Exaggerated textural brushstrokes add a sensual feel to the sur-face. In addition, the edges between forms are exaggerated, made crisper like stain glass, emphasizing line and pattern.

Jakki Kouffman
Red Rock, Near Creek
Acrylic on canvas
40" x 30" (102cm x 76cm)
Collection of New Mexico Arts, Art in Public Places,
San Miguel County Courthouse Annex

Slow drying acrylics have a longer open time, which means they stay wet longer than normal acrylic paints. Plus, when the slow-dry paint layers become dry to the touch, you can still rework them for a day or two by using any of the slow drying mediums, gels, thinners and/or water. These products can be added directly into fresh paint color, or applied straight over a dried layer to rework it. However, once a paint layer has been drying for more than a day or two, it may not be possible to revive it, and then it's best to apply new layers of fresh paint. There are a variety of extended paints. The best results will be obtained using those that stay wet more than twenty-four hours, like Golden's OPEN Acrylics.

Materials

- **Paints:** Slow drying acrylic paint
- **Surface:** Any painting surface
- **Painting Tools:** Brush, palette knife
- **Other:** Mixing palette, slow drying acrylic medium, slow drying acrylic gel, slow drying acrylic thinner, water

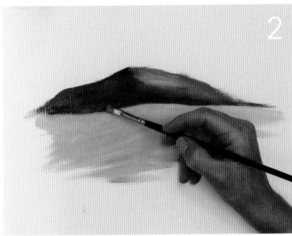

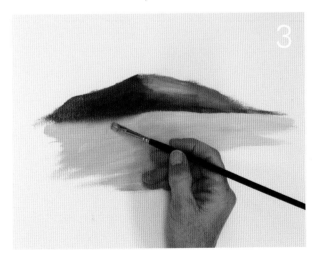

1. Apply slow drying acrylic paint

Using two slow drying acrylic paint colors, paint two shapes which touch, creating a hard edge. Let dry for several hours.

2. Resoften dried areas

With a brush, apply a slow drying acrylic medium, gel, thinner or water over the dried colors near the area where the two colors touch. Let this remain on the dried paint layer for a few minutes to resoften the paint.

3. Blend

With a brush, rework the softened color layers to create a smooth transition or softer edge between the two shapes.

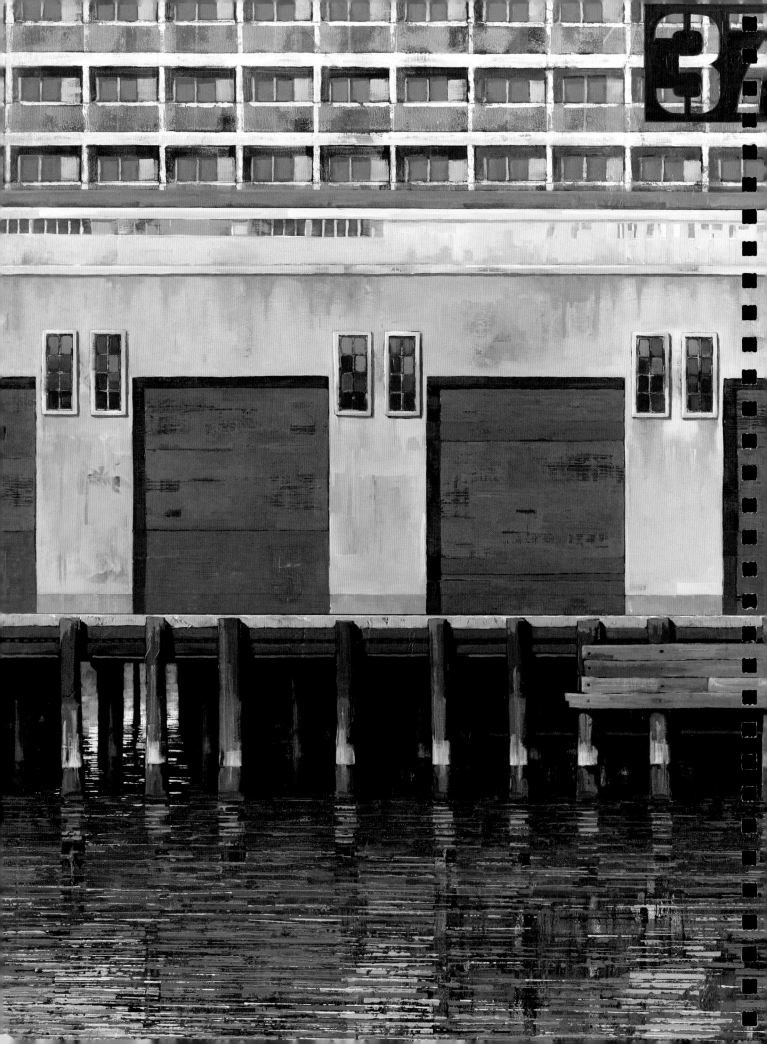

Section **3**

CHANGING PERSPECTIVES

For centuries a painting was seen as a "viewing window." Most images included a background, foreground, horizon line and fixed perspective. Cubism emerged in the early twentieth century, offering an alternative to the way an image was perceived. Using multiple perspectives in the same image, the fixed viewing point was eliminated, adding a new sense of movement and an interactive approach to viewing art. Cubist masters Pablo Picasso and Georges Braque spearheaded these concepts, while contemporary artists such as David Hockney continue to push them even further. New concepts are continually emerging based on how we really see. In real life, our eyes constantly move, darting around from close-up detail to the distant horizon. We remember an event or scene using a combination of snapshot views taken with our eyes from multiple perspectives. Multiple viewing points in a painting can often feel more real than a conventional photograph taken by a camera. On the other hand, going against our expectations of visual reality can feel surprising, upsetting or jolting to one not familiar with this new way of seeing in contemporary art. The styles in this section reflect the artists' preference to work with these new concepts and to involve the viewer in perceiving more actively.

Catherine Mackey
Pier With Cruise Liner
Acrylic and mixed media on wood panels
65" × 48" (165cm × 122cm)

An image that combines indoor spaces with outdoor environments can convey a sense of spaciousness, freedom and movement. This journey through both natural and human-made environments often employs a broad spectrum of light and shadow effects ranging from natural light sources to incandescent. Hyperrealist painter Gerard Boersma takes us on a magic carpet ride with his paintings through the world's street corners, shops and stores to underground subways. Emphasizing the theme of modern isolation and society, Boersma's work hints at subtle narratives where solitary figures are placed in mundane activities, suggesting the feeling of being alone even in a crowd.

The Artist's Process

Working from photographs and the computer to adjust color and composition, Boersma draws the image onto his painting panel in pencil and continues with paint, making changes when needed. Since he concentrates on one painting at a time, acrylic's fast drying qualities are an advantage, allowing Boersma to layer quickly. Clarity and realistic detail are important to Boersma, who wants his images to engage the viewer in a virtual experience. Artists inspiring to him include Edvard Munch, Johannes Vermeer, Max Ginsburg, John Currin and his great uncle, also a painter, Jopie Huisman. Super-realist favorites include Ralph Goings and Richard Estes.

TIPS
from the Artist

Practice! Paint what intrigues you. *Outliers: The Story of Success* by Malcolm Gladwell reports it takes ten thousand hours of time and practice to make something successful.

Gerard Boersma deliberately keeps a clean and organized studio, which he notes helps him paint good realism.

Other Art in This Style

- American scenes focusing on loneliness in a modern city: Edward Hopper
- Scenes using strong lighting contrasts: Masters such as Caravaggio and Rembrandt

Gerard Boersma
The Smoker (self portrait)
Acrylic on Masonite
37" × 28" (94cm × 71cm)
Private collection

Variation 1: Blur Boundaries

This trompe l'oeil painting depicts a storefront façade with incredible lifelike detail, and is even more startling when viewed in person. Here interior and exterior mingle. The artist's use of a black-and-white palette changes the viewing experience from an immediate association with it as a painting to a more conceptual one.

Paul Sarkisian
Untitled (El Paso)
Acrylic on canvas
14' × 21' (4.3m × 6.4m)
Photo by Eric Swanson

Variation 2: Simplicity and Repetition

Areas are simplified, creating a bold abstracted landscape. Here the eye travels back and forth between the outdoor and indoor spaces, assisted by the repetition of green used in both places.

Hamish Allan
House and Hills
Acrylic on canvas
24" × 24" (61cm × 61cm)
Collection of the artist

More Variations

• Experiment with small collages using interior and exterior images to find unique ways of combining the two.

• Go out on a photography mission to find shots that naturally combine interior and exterior, like storefront windows that reflect the street while revealing the store's interior.

• Journal about your emotional response on how interior and exterior spaces differ in feel, and paint that.

Painting a convincing image that portrays both indoor and outdoor spaces requires a broad range of light and dark values. One surefire way to obtain a variety of these tones in a painting is to pre-mix a full range of colors ahead of time, offering maximum potential. Here is my favorite full palette to achieve this.

• Select Optimal Colors for Maximum Color Mixing. You need a full palette to obtain a full range of colors. Full palettes contain both a warm and a cool for each of the three primary colors, plus white. Adding other colors such as black, green, orange and violet add convenience, but are not necessary.

Along the outer rim of a large palette, apply paints in an arc, allowing ample space in the middle for mixing color and placing mediums, if desired. Squeeze out a generous amount of each of these suggested colors plus Titanium White:

1. Choose either Hansa Yellow Light or Cadmium Yellow Light for a cool yellow.
2. Use either Hansa Yellow Medium or Cadmium Yellow Medium for a warm yellow.
3. Select from: Cadmium Red Medium or Light, Naphthol Red Medium or Light, Pyrrole Red or Pyrrole Red Light for a warm red.
4. Quinacridone Magenta, a cool red that mixes a clean violet.
5. Ultramarine Blue, a warm blue.
6. Phthalo Blue (Green shade), a cool blue.

• Add a Tinted Swatch Near Each Color. Modern colors look very dark on the palette, while mineral colors appear bright. It can be deceiving to see the colors only in their thick form or mass-tone. Adding white, which turns the colors into a tint, offers different results depending on whether the pigment is modern or mineral.

Next to each color, add a small amount of white in a separate mixture, giving you a reminder of the true potential of each color. In the tinted form, modern colors get brighter, while mineral colors get chalky and muted.

• Pre-Mix Lights. Most paint colors unmixed out of the tube have a middle to mid-dark value range; therefore, a palette using only paint directly from the tubes will produce a dark painting. Pre-mixing a few light values before starting to paint helps solve this problem. Make a 20:1 mixture of Titanium White with red. If the resultant mixture appears too pink, add more white. Make a second light mixture using the same ratio of white mixed with yellow, and a third using white and blue.

• Pre-Mix Darks. There's nothing wrong about using black straight from the tube. Darks are further enhanced, however, by the addition of pre-mixed custom blacks. Make a mixed black combining a modern red and blue (i.e., Quinacridone Magenta with Phthalo Blue) and a small amount of any yellow. Test your mixed black by adding a small amount of white in a separate mixture to see its tinted version of gray. Make one or two more mixtures using the same three colors, but vary the combination ratios to make rich dark browns and cooler or warmer grays.

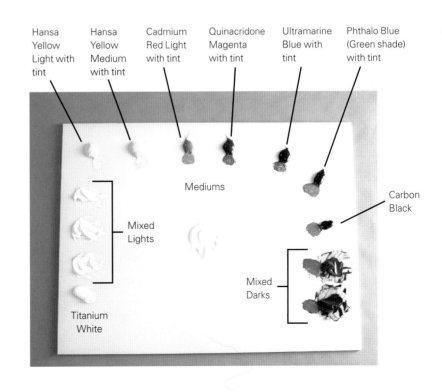

Hansa Yellow Light with tint

Hansa Yellow Medium with tint

Cadmium Red Light with tint

Quinacridone Magenta with tint

Ultramarine Blue with tint

Phthalo Blue (Green shade) with tint

Mediums

Carbon Black

Mixed Lights

Mixed Darks

Titanium White

Combining multiple perspectives in the same image allows a variety of viewing points, movement and an invitation for multiple interpretations. This idea has been used by many artists in the twentieth century, most notably with Cubism. Ines Kramer's imaginary cityscapes with a kaleidoscope of planes offers unexpected associations and an overall surprising image. Born in Caracas, Venezuela, Kramer has moved and traveled extensively. Through this rich variety of surroundings Kramer developed a habit of synthesis, absorbing images from all sources and arranging them in new and different ways.

The Artist's Process

Kramer calls herself a "hunter-gatherer of images," and she goes on several photographing trips each year, later reassembling these images into landscapes of her imagination. Her current interest in urban landscape takes her to large cities, where she captures objects close up such as windows, doors, architecture, rooftop gardens and city trees. Placing close-up shots next to far shots in these reconstructed cityscapes suggests a live city experience with its jostling, overstimulating space.

Kramer takes photographs with the intent of capturing a shape or object, not taking a great photograph. This way, she doesn't mind cutting them up or overpainting the photos later. After manipulating them on the computer, Kramer prints out the images, cuts them up and collages them onto a painting surface, which she overpaints with acrylic paint. Some images are completely buried with layers of opaque paint, while others are still visible through layers of transparent glazes. Kramer also adds watercolor, colored pencil, lead pencil and found imagery. Working in layers, Kramer has found the fast drying nature of acrylic works best. Acrylic is a glue as well as a painting medium, making it a good choice for collage, without harming the photographs as oil would.

TIPS
from the Artist

Make sure to have a designated space devoted exclusively to your art—even if it's just a TV cart (my very first "studio")—so that you can work on or just look at and think about your work every day. The easiest way to become inspired and stay inspired is to do the work every day. Avoid teachers whose students' work looks just like the teacher's—that teacher will never help you find your own vision.

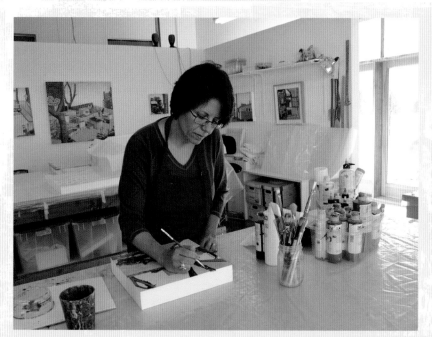

Ines Kramer in her Santa Fe studio. Her large size paintings can contain over twenty-five photographic images. The collaged photographs give her a jumpstart and add inspiration as she continues to change and shift the work.

Other Art in This Style

For multiple perspectives, check out Cubist artists such as Pablo Picasso, Georges Braque and Paul Klee. David Hockney works with a unique contemporary version of Cubism especially visible in his photo collages. See also Wassily Kandinsky, David Salle, James Rosenquist, José Clemente Orozco and Richard Diebenkorn.

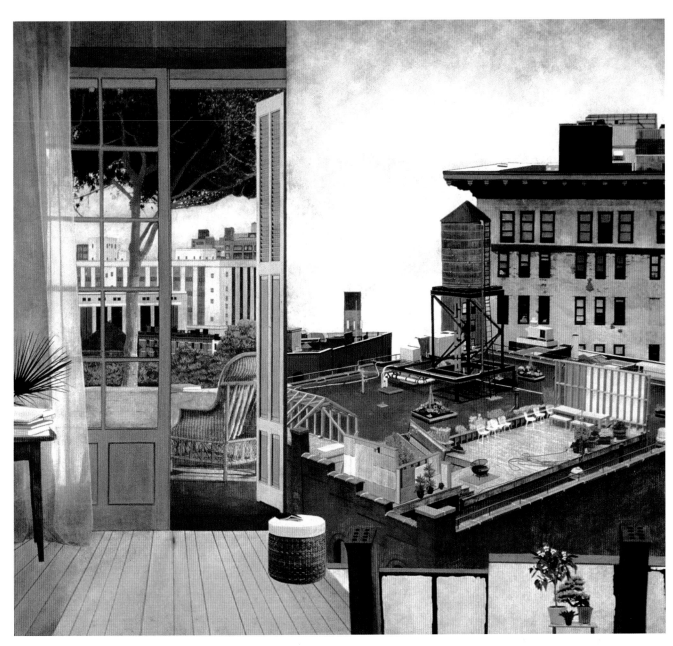

Ines Kramer

Rooftop Eden

Acrylic and collage on panel

32" × 36" (81cm × 91cm)

Variation 1: Combine Separate Panels

Joining separate painted panels contrasts varying perspectives in this assemblage painting.

Catherine Mackey
Whiz Burgers
Acrylic and mixed media on wood panel
24" × 53" (61cm × 135cm)

Variation 2: Merge Different Images

Combine two completely different images. Here a landscape and abstract designs are spliced into geometric shapes and reassembled into a completely new image.

Mary Morrison
Grasslands
Assembled acrylic painted fragments on panel
36" × 45" (91cm × 114cm)
Collection of The Herman Memorial Wellness Center, Houston, TX

More Variations

- Pick one particular topic that interests you. Gather all the images of these you can from varying sources: magazines, photocopies from books, your own photos and drawings; and collage these together in unusual patterns and arrangements.

- Find and cut out pieces of color with no recognizable imagery (i.e., paint swatches from home decorating stores, cut pieces of ads and product labels). Arrange these and collage them to create an abstract or color field, with or without the addition of painted areas.

- Exaggerate viewpoints: Pick a subject you like: people, landscapes, skies, pets and animals, food, clothes, etc. Photograph it several times from different viewpoints. Collage these by overlapping images.

- Create a painting that has no horizon line, thus eliminating a finite point of view.

Horizontal lines in a painting are easily interpreted as a horizon, and can add a grounded feeling to the work. Many abstract styles add a horizontal line to the image to ease visual tension, while others eliminate it to move the viewer into another reality. Here are some examples to illustrate this idea.

Tip

A horizontal line is a grounding tool, not an essential element in a work. It can be used or avoided depending on your intent for the image.

Evoking a Landscape
This painting contains very few elements. With only three colors, the composition consists of a gradation of two colors in the top area and a simple horizontal band of color for the bottom. Note how easy it is to interpret this as a landscape, even with nontraditional sky and ground colors. It is our sense of being human, our relationship with the planet and its continual pull of gravity that defines the essence of this viewing experience.

No Horizon Line Increases Visual Tension
This painting has no obvious horizontal lines, giving it a floating quality with a visual tension that can offer a new and vital viewing experience.

Adding a Horizon Line Grounds the Viewer's Perspective
Here the same painting is changed completely with the addition of a simple horizontal line. There is a new feeling of comfort and ease in the viewing.

COMPOSITE ARRANGEMENTS

This style, also called assemblage, is a form of artistic construction where multiple individual images and surfaces are combined to create a new, but segmented larger whole. Catherine Mackey relies on her experiences as an interior architect to create an unusual body of work using this process. In a definite reaction to her former career's pristine and controlled nature, her paintings add elements of dirt and grit. Collisions of color and fragments in her urban environment catch her eye as she notes inadvertent beauty, searching for urban decay on walls that carry a visual history of stories about people.

The Artist's Process

Ten to thirty bits of found wood, reworked and often repainted, can always be found hanging around Mackey's studio. She uses these to play and arrange. Allowing for accidental associations and chance, her process carries an unpredictable timing. Texture is important, and she'll often use building materials like ceramic tiles or Sheetrock compound, pressing other objects into it. She uses acrylic for most of her painting purposes. Her techniques are varied, and include stenciling and thick stippling for adding text in relief. Colored areas are sanded, scratched and washed down. Scrubbing creates an accelerated look of aging. When pieces come together

⟩ TIPS from the Artist

Mackey works mostly from photographs in her studio. Yet even with plenty of photographs on hand, there are times when she still needs to energize her work and/or attitude, and ventures out with her camera exploring for more. This will inevitably reveal something new. She recommends one of her daily rituals: spending ten minutes every night looking through art books she might not have picked up for a while. Falling asleep while thinking of new ideas keeps her creative energy alive.

in a way she likes, she connects them by constructing a backing frame, then continues painting them together as one image.

Artists who inspire Mackey include: Robert Rauschenberg and the complete freedom he used to work with anything, repeat imagery, and reuse things in other works; Frank Auerbach's thick layers using lots of subtraction and peeling back; Anselm Kiefer's monolithic early work, using massive scale and architectural composition with miles of field; famed graffiti artist Jean-Michel Basquiat; David Ireland's unusual installations.

Catherine Mackey surrounded by a variety of assemblage panels and materials in her California studio.

Her term "architectural palimpsests" aptly describes her interest in graffiti, signs and wall writing. Ripped posters stuck onto each other year after year build up with a patina she can't resist. She peels these treasures off their original surface, soaking them in a tray of water to become unique collage fodder.

Other Art in This Style

- Assemblage artists: Robert Rauschenberg, John Baldessari, Louise Nevelson, Mike Kelly, Jennifer Bartlett
- Cubist masters: Georges Braque and Pablo Picasso
- Fluxus Movement artists
- Marcel Duchamp's readymades, Kurt Schwitters, Man Ray, Joseph Cornell

Catherine Mackey
Tony's Journey
Mixed media on wood panels
24" × 238" (61cm × 605cm)

Variation 1: Use a Variety of Materials

William Dunlap uses materials both found and fashioned, often confusing viewers over what is made or found. The implied narrative is made exciting and contemporary by Dunlap's arrangement, angled placement and use of materials.

William Dunlap
Landscape & Variable: Landscape Askew
Polymer paint on canvas (with wood, slate, leather, mixed media)
41" × 180" (104cm × 457cm)
Collection of Washington Convention Center, Washington D.C.

More Variations

- Assemble a collection of objects and images that you find or make. Do not permanently adhere the elements together in the beginning to allow for maximum play and flexibility. As you find arrangements you like, photograph them for later use as reference, while continuing to rearrange.

- Dig out old paintings and drawings that are no longer of interest to you. Cut them into new shapes and pieces. Rearrange them on a new surface or over another painting.

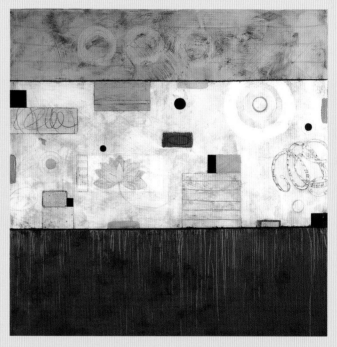

Variation 2: Assemble Non-Related Sections

Three distinct sections offer a playful dialogue about the artist's interest in nature. During a winter visit to a botanical garden, Don Quade noted flowers trapped in ice. The combination of abstraction and strong divisions turned his experience into a metaphor for space and time. The top sections refer to clouds and sky, while the bottom represents rain.

Don Quade
Winter Lotus
Acrylic, oil stick, graphite and paper collage on wood panel
48" × 48" (122cm × 122cm)
Private collection

ANTIQUE EFFECTS

When Mackey needs to make something look old, she likes to work with acrylic washes, alternating with subtractive scrubbing. Here is a technique to get similar results, especially helpful with found objects and collage items that look too new.

Tip

Before starting, hold your surface up to the light, and notice the sheen. If some areas are matte and some are glossy, you'll have a greater variety of effects. Optionally, you can prepare the surface by applying matte and semigloss mediums or gels separately in several places on the surface. Let dry before starting. To emphasize the stained effect even more, reapply semigloss acrylic gel in between wash layers, letting it dry before adding any more washes.

Materials

- **Paints:** Any acrylic paint colors in earthy tones such as black, brown, olive green and rust (suggested colors: Burnt Sienna, Quinacridone Nickel Azo Gold, Viridian Green Hue, Transparent Red Iron Oxide, Green Gold, Bone Black)
- **Surface:** A primed surface with a semigloss or matte sheen
- **Painting Tools:** Any brush
- **Other:** Dish scrubbers or sandpaper, water, spray bottle, paper towel or rag

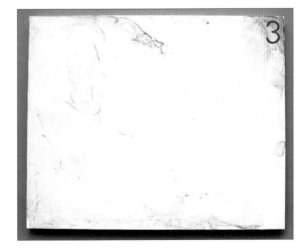

1. Apply Acrylic Washes

Wet the painting surface with enough water to form small puddles. Select a few colors and dilute heavily with water. Apply all the colors randomly over the wet surface. Lightly spray more water over the applied paint and entire surface. Allow the paint to puddle up and move around on its own. Let this dry on a level surface.

2. Scrub the Paint

If the dried stains from the previous step are too noticeable, reduce them with this step. Select a dish scrubber or any abrasive tool such as waterproof sandpaper. Apply water to the surface, then remove some of the paint using your scrubber, applying medium pressure in a variety of scrubbing directions. Wipe the excess paint off with a paper towel or rag, and let dry.

3. Repeat Steps

If the stains are too subtle, you can repeat steps 1 and 2, layering over the previous one, until you've obtained the desired results.

A New Use for Old Water

Instead of diluting a fresh batch of paint for the washes in step 1, use some leftover dirty paint water from your studio.

COLLAGE

The term collage comes from the French word *coller* which means "to stick." A collage incorporates multiple images applied to a surface, usually overlapping one another to partially reveal and partially cover. A whole new image emerges, offering multiple perspectives.

Collage artist Nancy Scheinman takes her paintings to another level by making most of her unusual collage materials. For instance, she washes hand-embossed sheets of copper with acid to create patinas that she nails onto wood panel, which she paints or prints. The unusual formats and ways she combines these materials add a unique quality to her work.

Scheinman presents and assembles new stories incorporating themes such as finding balance in life or the myth of a purer past. Her signature motifs include towers, borders, woman protagonists, birds, leaping dogs and red circles—her personal symbol—which she presents in dreamlike landscape. She presents her stories in snippets, allowing the audience to bring their own experience and interpretation to the work. Using the framework of a modernist geometric grid, borders visually contain the multiple stories within each piece, which are slowly revealed to the viewer.

The Artist's Process

Scheinman freely applies layers of paint and materials, and, just as freely, takes them off. Like fabric in a quilt, she cuts and layers sheets of copper paint and patterns, and collages them together with nails, tacks and antique materials, literally connecting the past with the present. She is inspired by the late contemporary artist Hollis Sigler, whose work contains an admirable strength in dealing with personal narrative; as well as Italian Baroque painter Artemisia Gentileschi, a bold artist who dared to represent historical scenes at a time when it was not considered appropriate for women artists. Gentileschi was the first female painter to become a member of the famed art academy in Florence.

Photo by Robert Creamer

Nancy Scheinman at work in her Maryland studio. A visual storyteller, her use of personal narratives and internalized images from extensive travels are transformed into collective myths and pieced together as part of a universal, spiritual and domestic experience.

Other Art in This Style

- Contemporary artists David Salle, David Hockney, Jim Dine and Gilbert and George
- Collage work of modernists Pablo Picasso, Georges Braque, Henri Matisse, Joseph Cornell, Man Ray, Robert Motherwell and Peter Blake
- Merz pictures of collage artist Kurt Schwitters

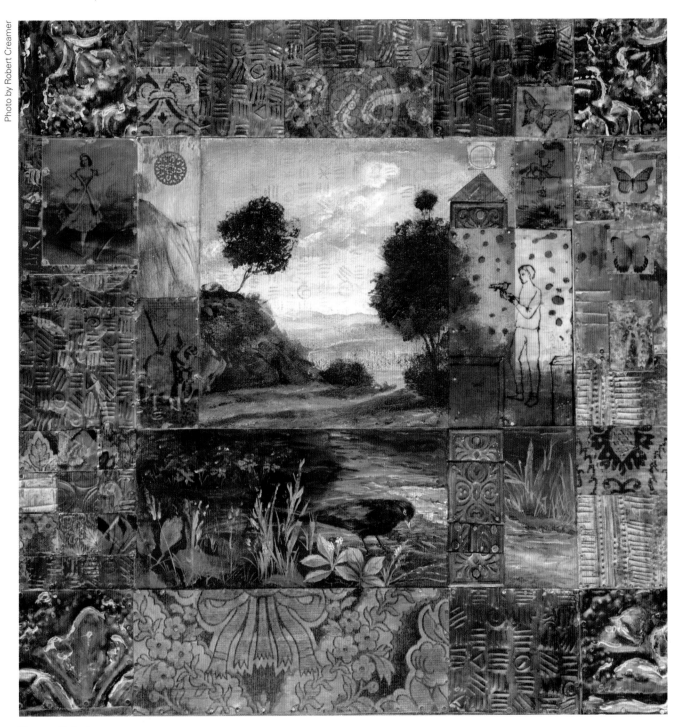

Photo by Robert Creamer

Nancy Scheinman
Repeated by a Bird—Melody
Acrylic; canvas; antique tin; brass; etched and
inked vinyl; hand-embossed printed, painted
and patinated copper on wood panel
21" × 21" (53cm × 53cm)

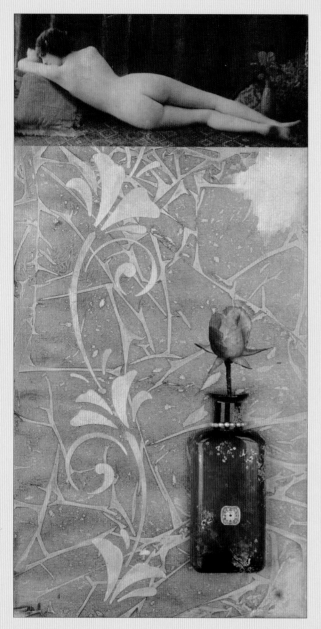

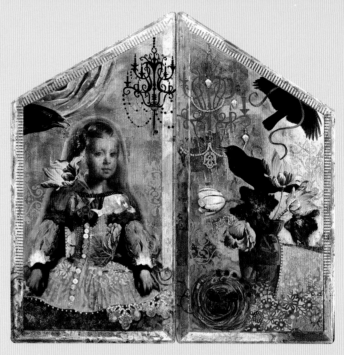

Variation 2: Unusual Formats

Old covered doors are used here, adding an interesting shaped surface resembling a house or shrine. The image is a tribute to Diego Velázquez, painted in the ornate style of his time.

Darlene McElroy
Ode to the Masters
Acrylic on panel with image transfer, collage and gold leaf
39" × 39" (99cm × 99cm)

More Variations

- Find printed images to cut out for a collage, but cut them with excess borders to create shapes that differ from the images themselves.

- Set up a still life using one of your paintings as the backdrop and assembling real objects in front. Photograph the setup to use as a reference for a whole new painting.

- Collect and save the numerous paper items you receive daily in junk mail, wrappers, product labels, etc. Color, cut, mix and match them to create something different.

Variation 1: Merge Photography with Paint

The use of transfer techniques allows an interplay between photography and paint. A photographer with a theater background, Cate Goedert plays with dramatic lighting and atypical formats. A copyright-free photograph in the top portion of the painting is kept transparent and transferred onto a painted background. The bottom portion of the painting contains a photograph that Goedert shot, as well as paint stenciling, crackle paste and textured surfaces. (See page 21 for the digital transfer technique.)

Cate Goedert
Repose
Acrylic and mixed media on canvas panel
16" × 8" (41cm × 20cm)

A collage usually combines paint with other materials. Paper, fabric, magazine images and other printed imagery often use inks and dyes that are not lightfast or permanent. Thicker materials like cardboard or heavy fabric can create a raised edge and present another challenge for artists who prefer the edges to transition smoothly into the painting. A smoother surface can be obtained by applying an acrylic gel over the collaged materials. Fading can be reduced by using a gel with UV protection.

Tip

The gel adds a nice handmade texture to the final surface. Generally, a thick gloss gel will suffice. Use a matte gel if you prefer a slightly cloudy, veiled layer that will somewhat obscure the underlying painting. If you desire a glassy smooth surfboard-like finish, you can add a layer of pourable acrylic. See page 127 for additional pouring tips.

Materials

- **Surface:** Any collage acrylic painting that is finished or in-process on any surface
- **Painting Tools:** Palette knife or other wide, flat application tool
- **Other:** A thick gloss acrylic gel with UV protection (if unavailable use two separate products—a gel and a UV product)

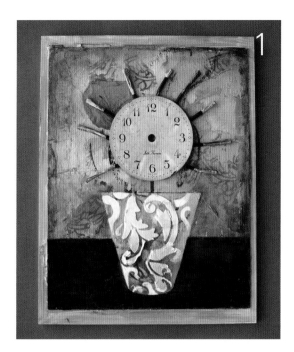

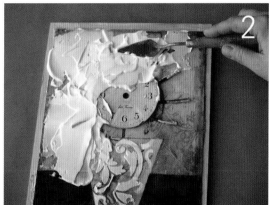

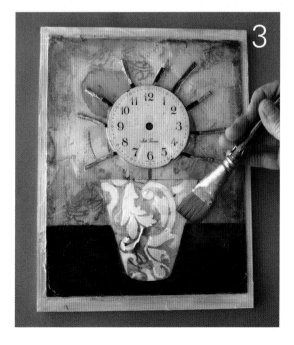

1. Preparation

Select a painting with texture or relief edges that needs smoothing. Using a knife with a stepped handle so that your hand will not drag through the gel while applying, load up the back of the knife with a generous amount of the gel.

2. Spread the Gel

Spread the gel evenly over the entire surface. While applying the gel, keep the knife lifted slightly off the surface, at least by ¼ inch (6mm), so the knife never actually touches the surface. This will allow the layer to be thick enough to cover all the texture and relief. If your edges are thicker than ¼ inch (6mm), apply the layer more thickly, or apply a second layer after the first has dried. Additionally, you can add more objects or images into the gel while wet and they will adhere. The gel will turn clear when dry.

3. Add UV Protection

If the gel used in the previous step does not have UV protection, then apply another layer using a UV product such as Golden's Archival Varnish. Follow the label's instructions, diluting if required, and brush or spray accordingly. The more coats of a UV product you apply, the longer the colors will remain intact and resist fading.

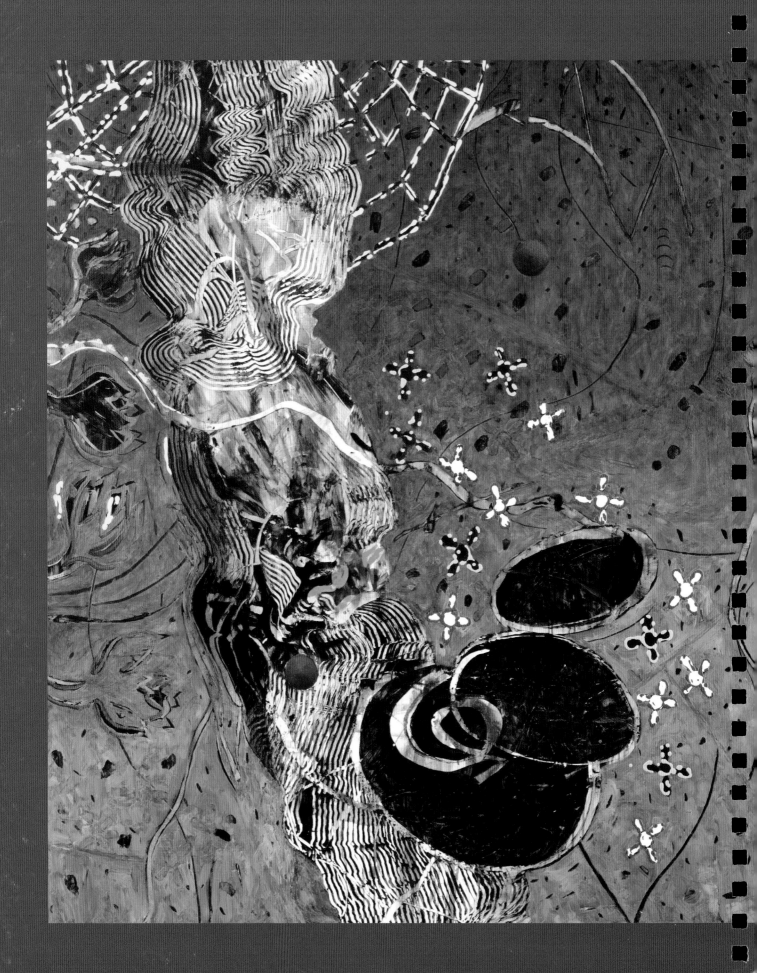

ENGAGING THE PICTURE PLANE

Images that create the illusion of coming forward confront the viewer, or break the illusion of pictorial depth, and attempt to visually engage us on the front surface of the canvas. This is a significant change from the Renaissance "window" where attention to the front picture plane was avoided. The styles in this section contain works which are sometimes bold, blatant and appear to meet us head-on. Shock imagery quickly comes to mind as one way to create this effect. Highly textured surfaces, flatly painted forms and shallow space can also bring our attention to the front picture plane. This section offers a variety of styles and approaches to engage the picture plane, using a range of aesthetic aspects.

Jim Waid
Blue Shimmy
Acrylic on canvas
78" × 96" (198cm × 244cm)
Collection of Kevin Osborn, Tucson, AZ

Mapping involves a schematic display that is readily seen in maps, science book diagrams and graphs. A painting that uses mapping can create a sequence in the way it's viewed, as in comic book strips, scrolls and altered books.

Dannielle Tegeder makes use of this new approach, inspired primarily by the architectural blueprints and technological sketches she has been exposed to since childhood. Her use of this style, along with mechanical references and forms, creates abstract fields that evoke postmodern visions of the future. The spaces can feel disorienting with no recognizable horizon line, floating architectural fragments and a precarious balance of objects.

The Artist's Process

Tegeder sands layers of acrylic molding paste on canvas over panel to create a smooth drawing surface, where she then draws with pencil. She then layers paint, transfer skins and gels together to create the final textured surface. For her, adding handmade elements and imperfections offer a humanizing element and balance the hard edges and analytical motifs. Using an intuitive process, Tegeder keeps the end result unplanned, allowing each step to respond to the one before. The sense of space created in Tegeder's paintings shifted when she started working with installations and sculpture. *Inropataciland* (page 77) shows her earlier work using a flatter space, compared with *Deconia* (page 77) which shows a more expanded space using angles and loosely worked areas.

Other Art in This Style

- Contemporary artists: Squeak Carnwath, Ed Ruscha, Joyce Kozloff, Newton and Helen Mayer Harrison, Julie Mehretu, Vernon Fisher, Öyvind Fahlström, Jean-Michel Basquiat, Pat Steir's early work, William Wiley
- Egyptian hieroglyphics
- *The Map as Art* by Katharine Harmon, a book on contemporary artists using this style

Dannielle Tegeder in her New York studio. Tegeder is inspired by cities and charts organizing information about people, like transportation routes, population charts and aviation maps. Organizing color and form is integral to Tegeder, and she allows some type of narrative to come through and read like a map.

Dannielle Tegeder

Inropataciland: White Winter City with Dot lower Tunnel Routes, Love Circle Production Expulsion Center, with five station Route, Twin Station Igloo Housing, with New Central Hospital and Lace Grid Station, multiple Box Square Hotel Housing and 27 circle; Storage from Above Ground and Below Ground; and Sideways color coding Grid, with Triangle Training Center, 2005
Acrylic, ink, dye, pencil, design marker and gouache on paper
55" × 79" (140cm × 201cm)
Images courtesy of Priska C. Juschka Fine Art, New York, New York

Dannielle Tegeder

Deconia: Thermal Atomic Rate at Red Midnight 2007
Acrylic, ink, colored pencil, graphite, gouache and pastel on paper
55" × 79" (140cm × 201cm)
Images courtesy of Priska C. Juschka Fine Art, New York, New York

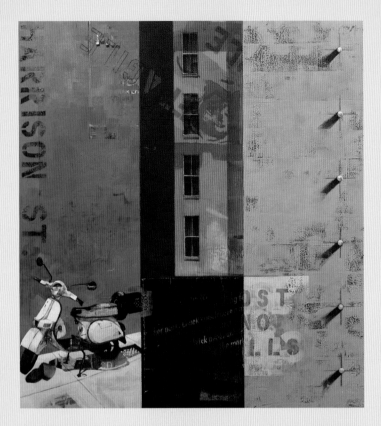

Variation 1: Strong Divisions

This composition presents imagery within strong geometric divisions, presenting a flat diagrammatic space.

Catherine Mackey
Harrison Street Scooter
Acrylic and mixed media on wood panel
48" × 45" (122cm × 114cm)

More Variations

- Secure several maps and diagrams onto a surface. Extend elements from one diagram into another, exploring how to integrate the aspects and create a flow.

- Collect diagrams and graphs of all kinds. Select your favorite and replicate its format, replacing the information formerly displayed with personal imagery. Find multiple ways of expressing the same concept (pictures, text, lines, arrows, products, shapes, etc). Books on tarot will often show special "layouts" for readings that can be used as inspiration for compositional structures.

- Instead of writing entries in a journal or diary, find a new way of presenting events. For instance, draw or list images from your day by displaying them differently, e.g., chronologically, by priority, like a family tree, circularly, etc. Use text, arrows and pictures to get your point across.

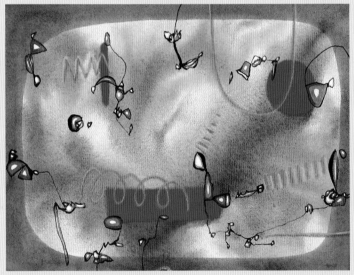

Variation 2: No Horizon Line

With no horizon to ground the viewer, Keith Morant creates a dialogue between the free-floating forms by harmonizing, contrasting, and using structural and directional forces.

Keith Morant
Airs & Graces II
Acrylic and oil pastel on canvas
18" × 24" (46cm × 61cm)
Bryce Gallery

Tegeder's paintings end up with a multi-textured finish, but she still likes to start with a very smooth surface, facilitating detail and line work. Here is a technique simulating her surface preparation.

Tip

To lend a warmer white color to the paste, add a small amount of Transparent Red Iron Oxide (about two–four drops per eight ounces of paste) before applying the paste to the surface. Other colors can be added in more quantity to the paste to create a colored ground.

Materials

- **Surface:** Any rigid surface
- **Painting Tools:** A large flat plaster knife or other application tool
- **Other:** Acrylic molding paste, waterproof sandpaper, paper towels or rags, water

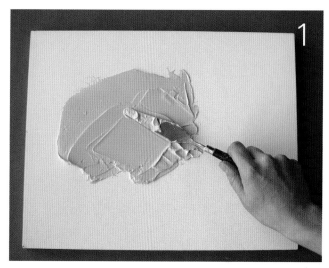

1. Apply Acrylic Paste

Using a large flat plaster knife or other application tool, apply acrylic molding paste onto your surface. Use a larger tool for a larger surface. Apply a generous amount of paste and smooth it the best you can. Let it dry at least twelve hours or until it's no longer cool to the touch.

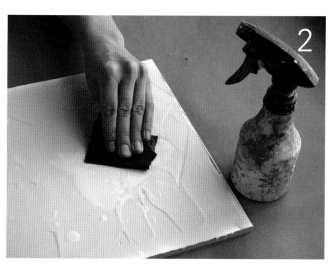

2. Wet Sand the Dried Paste

Using waterproof sandpaper (usually black in color, and sold at home improvement stores) wet-sand the paste surface by always keeping water between the sandpaper and the surface. Dip the sandpaper into water or use a brush or spray bottle to apply water separately to the surface. Using moderate pressure, sand in circular motions, continuing to add water at intervals into your sanding area. Wipe excess paint off frequently with a rag. Work the entire surface until smooth.

3. Repeat as Desired

Repeat with a second layer of paste, letting it dry before sanding. Keep repeating as desired. The surface will become unusually smooth with a dense feel. Drawing and taping are easily accomplished on this surface.

Content in images that confront the viewer head-on can be organized in two different ways: aesthetic or psychological confrontation. Confrontation using aesthetic concepts was spearheaded by German abstract expressionist Hans Hofmann, an influential artist and teacher, who used color relationships to enhance his "push-pull" spatial theory. Blocks of color with no recognizable imagery can create the illusion of an assertively forward or recessive backward movement.

Psychological confrontation uses imagery and associations that confront our societal, political, religious or moral values. This latter mode is easily seen in works by Frances Ferdinands, who uses her training in conceptual art to convey ideas on social and environmental concerns of postmodern society. In *Becoming One* (page 81), a package of Wonder bread becomes an offering in the lap of an ancient Buddha, addressing issues on global consumption.

Ferdinands wants the ideas in her works to take precedence. She uses humor to diffuse confrontation, which she incorporates into her work by mixing contemporary and historic sources with surprising juxtapositions.

The Artist's Process

Ferdinands' paintings start from personal experiences she transforms to the universal. She allows the process to take whatever time it needs. Ideas often take years to percolate, and sometimes work needs to be put aside for her to return to later. She allows her process full freedom, adding the risk that some pieces can and will get destroyed or overworked. Multiple glaze applications create depth and richness to her color and surfaces.

TIPS
from the Artist

Everyone's life is sufficiently interesting to provide fodder for unique work. You don't have to look "out there." Capture your vision and combine it with technical mastery. Great art has to touch the soul. The harshest critic is yourself.

For inspiration, Ferdinands researches art history. Artists that inspire her include: Edward Hopper, Jim Dine, Jasper Johns, Robert Rauschenberg, as well as pop artists, conceptual art and surrealist movements.

Other Art in This Style

- Confrontational works of Hans Hofmann, Damien Hirst, Mike Kelly, Paul McCarthy, Otto Dix, Eric Fischl, John Heartfield, Barbara Kruger
- Realist Impressionist painter Édouard Manet created controversial work for his time in the mid-nineteenth century
- Pop artists like Andy Warhol

Frances Ferdinands

Becoming One

Acrylic on canvas

30" × 30" (76cm × 76cm)

Variation 1: A Direct Gaze

A Japanese fencing mask only slightly obscures the portrait's direct gaze. The mouth is hidden by leather, adding an intimidating quality.

Daniel Barkley
Cage 1
Acrylic on canvas
42" × 42" (107cm × 107cm)

(Below) Variation 2: Shockingly Bright Color

Fluorescent orange paint vibrates, layers collide and colors bounce off each other. Grant Wiggins likes his work to clash and uses advertising and corporate logos for the basis of his inspiration.

Grant Wiggins
Where Is Gibarian?
Acrylic on canvas
21" × 16" (53cm × 41cm)
Collection of Laurence Blake, Palmdale, CA

(Left) Variation 3: Add Surprise

An unexpected image is created by removing something expected, giving this work a disturbing quality. Darlene McElroy appropriates some imagery from historic painting, while adding her own. Paint and image transfers are used over stenciling.

Darlene McElroy
Maîtresse sans Visage
Acrylic and mixed media on panel
24" × 24" (61cm × 61cm)

Ferdinands often uses backgrounds that are simple yet luminous, creating a sensual contrast for her realistically painted imagery. This technique takes a simple yellow background and adds luminosity and a halo effect to frame or accent any centrally painted form.

Materials

- **Paints:** Heavy Body or Fluid Acrylic colors: Naples Yellow Hue, Indian Yellow Hue, Quinacridone/Nickel Azo Gold, Transparent Yellow Iron Oxide, Nickel Azo Yellow
- **Surface:** Any primed surface
- **Painting Tools:** Brushes, mixing knife, rag
- **Other:** Acrylic slow drying or glazing gloss medium

Finished Example

1. Paint a Colored Background

Brush-apply an opaque color, such as Naples Yellow Hue, over a primed surface, creating a solid, evenly applied undercoat. Apply a second coat if it appears streaky.

2. Apply Transparent Color

Generously brush-apply some uncolored slow drying medium or acrylic glazing medium gloss in the center of the painting, covering an area in excess of any central imagery you plan to paint later. Mix a transparent glazing color using medium to color in a 4:1 ratio. Using a brush or rag, apply the glazing color, starting at the corners and outer edges, where the strongest color will be. Continue spreading the glaze, moving towards the center. As you continue to spread the color toward the center, allow the color to dissipate. When the remaining colored glaze meets the wet medium in the center, the color will blend easily. Let the glaze dry fully.

Repeat this step using a variety of glazes. The example here uses Indian Yellow Hue for the first glaze, Quinacridone/Nickel Azo Gold for the second and Transparent Yellow Iron Oxide for the third.

3. Integrate With an Overall Glaze

The background now has a luminous quality from the several glaze layers. The central area, however, appears like a hole since color was withheld there. To integrate the center, a final glazing color is applied with Nickel Azo Yellow. But this time, brush-apply the glaze over the entire image, including the center. For added luminosity, apply another glaze using Interference Gold or Iridescent Gold.

While complex or overcrowded compositions have their place, a bold use of simplicity can allow a deeper insight into an idea. By isolating a particular form, fragment or area, the composition takes on a graphic quality.

Former figurative and portrait painter Joey Fauerso offers a great example of isolated imagery in the work pictured opposite. Isolating the figure from its environment allows it to be seen in a different way. When she expanded her medium to include installation and animation, the figure continued to remain her primary focus. Fauerso films people in various activities, and from this creates work that includes her films, stills and paintings from the stills. Fauerso sees animation as "moving painting" and her installations offer "epic paintings in time."

The Artist's Process

Fauerso warms up by working on fifty or sixty sheets of paper all the same size that are soaked then stretched. She experiments on these sheets, trying out new techniques, materials, surfaces and mediums. What she learns becomes part of her new series. She protects the backgrounds by coating the paper with matte medium. Projecting the stills onto the paper, she then traces the forms using thin washes of color. She masks the background around the form with blue tape and seals the edges with matte medium to ensure the background stays clean during painting. Fauerso then applies paint onto the wet paper using brushes, mops and giant assembled brushes to get big pools of color. Working subtractively, she wipes out areas of paint, then continues working to get the visual impact she wants.

Inspiration for Fauerso include artists Max Beckmann and Alice Neel, studying Eastern philosophy, reading favorite writers and poets such as Mark Strand, and listening to the music of Bach and Arthur Russell.

◇ TIPS from the Artist

More experimenting produces more discoveries. Avoid only working on finished pieces where you are invested in the outcome. Allow mistakes, since these can often lead to surprising techniques.

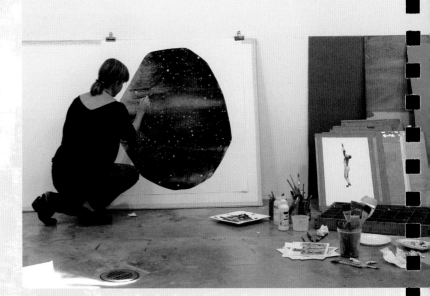

Joey Fauerso in her Texas studio. Her intent to convey the inside and outside of things, representing our physical and metaphysical boundaries, is aptly expressed in her work. She strives for strong graphic impact, contrasting form against the white page.

Other Art in This Style

- Andy Warhol and other pop artists
- Photorealist Chuck Close
- Susan Rothenberg, Jean Dubuffet, Leon Golub

Joey Fauerso
Wide Open Wide
(installation detail)
Watercolor and acrylic on paper
335 paintings, each 8.5" × 11"
(22cm × 28cm)

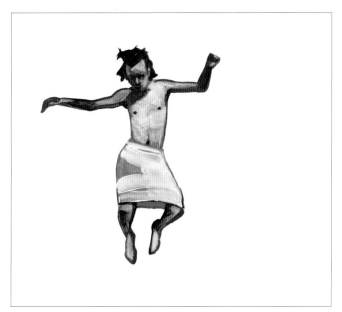

Joey Fauerso
Get Naked (Detail)
Oil and acrylic
on paper
8.5" × 11"
(22cm × 28cm)

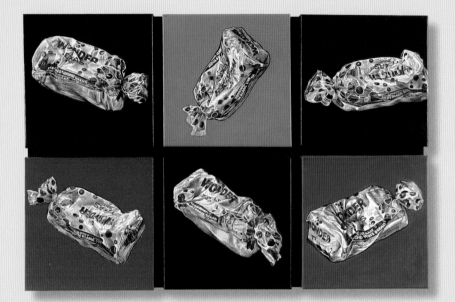

Variation 1: Repetition

A graphic quality is created by the use of bright, bold background colors, and repeating views of the same object.

Frances Ferdinands
Seven-Day Wonder
Acrylic on canvas, mounted on panel
24" × 36" (61cm × 91cm)

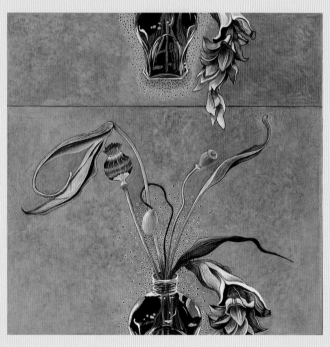

More Variations

- Find photographs or other images you like. Pick out one object or form in each image, and isolate it by painting over the background or cutting it out and placing it on a piece of colored or white paper.

- Starting with a picture you like, cut out the strongest forms, for example an animal, figure or flower. Recut forms further into smaller fragments or pieces, (i.e., figure is separated into arms, legs, hair, etc.), and experiment by placing the pieces separately on different backgrounds or combine some together on one common background. Take the original picture with its cut-out, and place it over other images to "fill" the hole with something else.

- Place strips of white cardboard over paintings to recrop and reframe images to view them in a new way.

Variation 2: Fragment

The unconventional divisions in this painting present separate fragmented sections of the same plant. Olga Seem researches unusual or extinct botanical flora. Her paintings incorporate material from reference guides containing various illustrations using dissections and close-up views.

Olga Seem
Duality (11)
Acrylic on paper on canvas
18" × 18" (46cm × 46cm)
Courtesy Couturier Gallery, Los Angeles, CA
and Davis & Cline Gallery, Ashland, OR

MASKING A SIMPLIFIED BACKGROUND

This technique is a great way to simplify a busy background, and isolate a singular form for emphasis or focus.

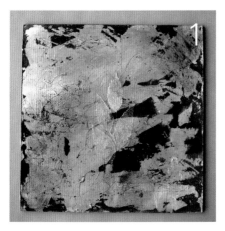

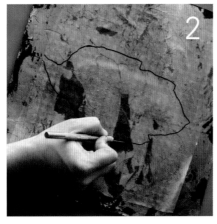

Materials

- **Paints:** Any acrylic paint
- **Surface:** A painting in-process with a busy background
- **Painting Tools:** Your choice of paint applicator such as a brush, sponge or commercial spray bottle (like Preval) or household water sprayer
- **Other:** Clear or transparent contact paper or masking paper, scissors or cutting knife, permanent marker

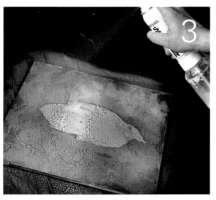

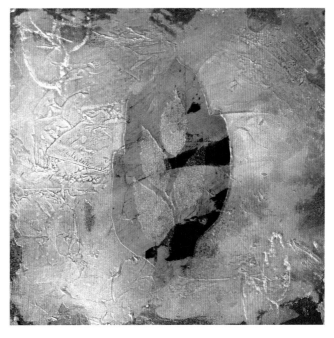

Finished Example With a Simplified Background

Selecting a dark color for use in the background will increase the brightness of the focus area, while a bright or light color will create more of a silhouette.

1. Select a Painting

Find a painting with a busy background that's in need of an emphasized focus area.

2. Cut a Mask

Apply contact paper or masking paper over your painting in excess of the focus area. (Pictured here is shelf paper found in home improvement stores.) Select a shape or section to single out as a main focus. Using a permanent marker, draw its outline onto the plastic. Transfer the plastic to an appropriate cutting surface, cut the outline with a craft knife, then situate the cut shape over the focus area once again.

3. Overpaint the Background

Select your choice of paint application (pictured here is a Preval sprayer found in home improvement stores), your preferred color and preferred transparency (here I am using fluid Iridescent Translucent Pearl mixed with some water to ease spraying). Keep the color fairly transparent at first by adding more medium or water if necessary. More control can be obtained by starting transparent and repeating layers until desired coverage is achieved. Overpaint the entire painting. Remove the remaining contact paper.

Enhancing an image by using decorative elements such as gems, gold leaf and painted detail adds a unique visual flavor. Depending on how the artist handles the embellishments, emotions and qualities such as playful, delicate, disturbing or disruptive can emerge. Jim Barsness combines pattern with pictorial space. Working on canvases covered in rice paper, his elaborate detail brings to mind an enlarged antique illuminated manuscript. Finished painted canvases are even left unstretched to be hung like a tapestry. Ancient meets contemporary with a touch of humor.

The Artist's Process

Barsness makes a point of seeking new subject matter that he knows little about. Looking outside himself for the unknown, Barsness puts in hours of research for each project. This process allows him to fall in love with different images and absorb them while actively engaging his own imagination.

Barsness has created a cast of characters that he reuses while continually inventing new ones. He works with acrylic like oil, using traditional glazing techniques, and layering to develop a depth in the character field. Other techniques he frequently uses include distressing the paint by sanding and using bright analogous glazes to enhance color (i.e., red gets an Alizarin glaze then Magenta—see page 131). Barsness also works with different materials such as glitter, silicone molds and casts from craft jewels, interference paints and flocking. Borders are hand-drawn.

Barsness is inspired by a wide range of art including graffiti; the Rubin Museum of Art's collection of Tibetan thangka paintings with hand-painted fabric borders; Northern Renaissance artists such as Pieter Bruegel the Elder, who painted huge crowd scenes; Early Netherlandish painter Hieronymus Bosch; Persian miniatures; and the stylization of works from Cambodia and Thailand.

photo by Trevor Frey

Jim Barsness in his studio. Barsness is intrigued by stylization and how it operates in various cultures. For him, pattern is a metaphor for social and cultural contexts, and these designs become a language.

TIPS
from the Artist

Start with what moves you visually, not to duplicate but to get you started. Instead of copying work you admire, try to emulate the way that artist thinks visually. Be prepared to make and embrace mistakes and find little moments that work. Find a path from all of the experimentation and mistakes and find your own territory. It takes a long time.

Other Art in This Style

- Gustav Klimt, particularly work from his Golden Phase; other artists from the Symbolist and Art Nouveau movements
- Dot paintings in Indigenous Australian art
- Ancient Italian mosaics; illuminated manuscripts from the Middle Ages

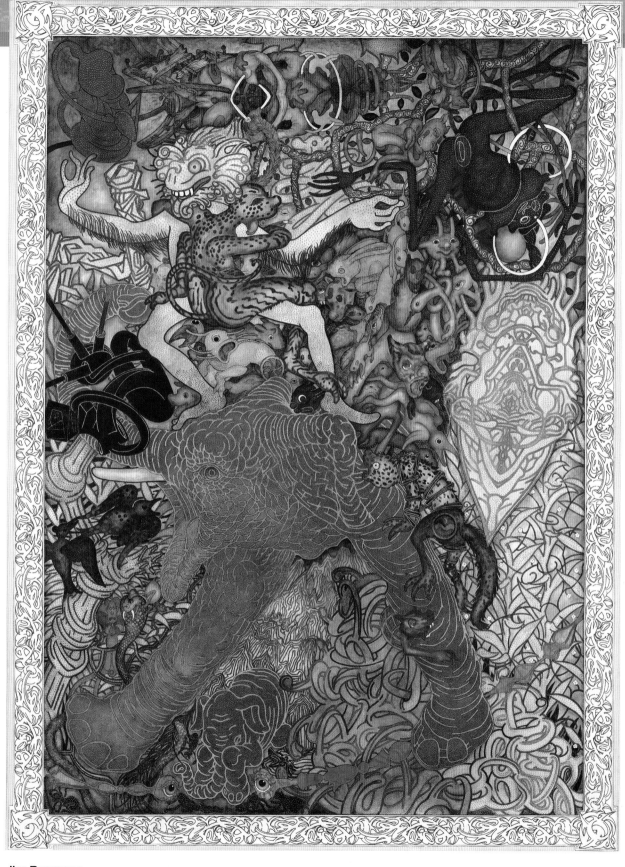

Jim Barsness

Hanuman's Rescue

Acrylic on canvas

90" × 66" (229cm × 168cm)

Variation 1: Combine Symbols With Realism

A pattern overlay infuses this image with symbols, transforming a portrait into archetype. Graphic elements combine with realism to create a complex image and rich surface.

Diana Ingalls
Ties that Bind
Acrylic on canvas with pencil and paper
20" × 16" (51cm × 41cm)

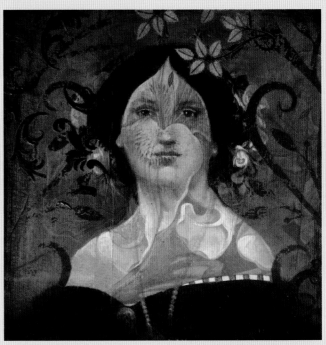

Variation 2: Mix Contemporary With Traditional

A formal portrait is applied as an image transfer over a vintage scrapbook from the 1800s, then painted and collaged to create a contemporary tribute to French Neoclassical painter Jean Auguste Dominique Ingres.

Darlene McElroy
Ingres Redux 2
Acrylic and mixed media on panel
8" × 8" (20cm × 20cm)

More Variations

- Collect patterns and designs from books, images, advertisements, labels, fabric and wallpaper. Cut out, trace or transfer these to your painting in select areas or overall. Allow pattern designs to be opaque, covering the painting underneath, or transparent, allowing the underpainting to be visible but partially obscured.

- Make your own patterns by starting with one thing: a symbol, letter, number or abstract shape. Photocopy, transfer or redraw this one item onto a larger surface. Use the same form repeatedly, attached to itself in a chain, turned, flipped and chopped in various ways and combinations with itself until a pattern is formed that goes beyond the initial singular element.

The painting surfaces in Barsness's work contain multiple techniques such as glazing, sanding, layering and casting. One of his techniques creates a jewel-like surface by applying paint color in small dot patterns using bottle applicators.

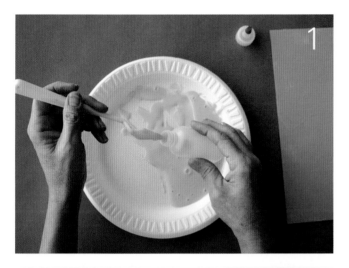

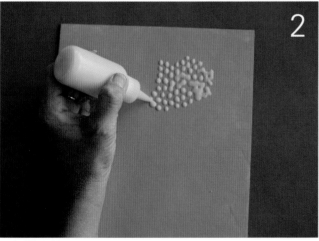

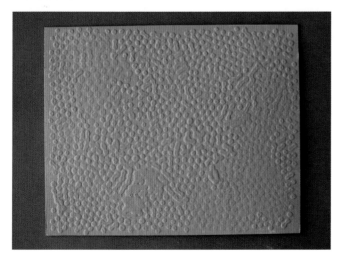

Materials

- **Paints:** Any acrylic paint color
- **Surface:** Any primed surface
- **Painting Tools:** Plastic squeeze bottle with small application nozzle, brush, palette knife, mixing palette
- **Other:** Acrylic gel or medium

1. Prepare the Materials

Select a paint color and brush-apply the paint onto your surface to create a background.

While the background dries, on a palette, combine this same paint color with acrylic medium or gel in a 1:5 ratio. If you use a thick gel, the stippling will hold higher peaks and stronger dot shapes, while fluid mediums create a softer texture. Using a knife, scoop this mixture into a plastic squeeze bottle or applicator found in hobby and art stores. Here, I combined Golden Fluid Cobalt Teal with Golden Soft Gel Gloss and placed the mixture into a squeeze bottle.

2. Apply Dot Patterning

Squeeze the paint from the bottle onto the painting surface, creating small dots. After all the dots are applied, let this dry for several hours or overnight. Make sure the dots are dry to the touch before any subsequent overpainting.

Finished Example

The raised dot pattern creates a jewel-like texture. Experiment with different sized dots, varying patterns and colors to embellish painted areas.

Tip

Pastry bags with icing tips can also be used to create varying dot patterns. For a different effect, try squeezing clear gel with no added color from a squeeze bottle directly onto a plain surface to create an underlying jewel-like ground, then apply thin paint color diluted with water on top.

HARD EDGE GRAPHIC

The phrase "hard edge graphic" immediately brings to mind geometric abstraction, popular in California in the 1960s, with roots going back to the late nineteenth century and later artists such as Piet Mondrian. Images in this genre use precision and clarity with crisp delineations between colors, readily visible in the work of Kasarian Dane.

Dane is concerned with the presence of a painting, its physical flat surface, and the canvas as an object in space. Instead of a spatial depth, Dane goes for a substance depth. He works on ⅛-inch (3mm) thick aluminum sheeting, braced to extend out about 1 inch (25mm) into the space from the wall when hanging for exhibition, which makes it appear to float (see *Untitled* page 93). The relationship of the exhibited paintings with each other and the space around them are key. The thin aluminum projected outward creates a presence that differs from a canvas with edges sitting flat against the wall.

The Artist's Process

To generate ideas, Dane works with the computer, experiments on paper, and collects bits of color from found ads, and other things he finds. His aluminum surfaces are first sanded, degreased and primed. He then divides his surface into horizontal and vertical areas. From there the process is allowed to flow, not planned too far ahead.

Dane has experimented with all types of paint applications, like knives and rollers, to get the surface exactly the way he wants. He prefers brush-applying matte acrylics to give a smooth sensual quality to the paint

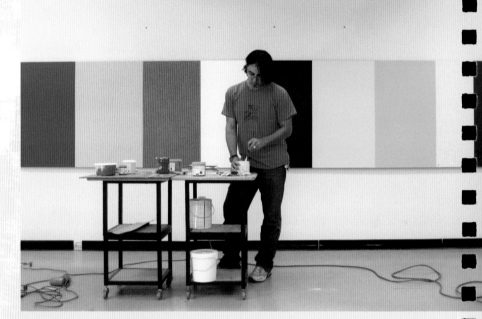

Kasarian Dane in his New York studio.

with a hint of brushstroke. He paints, repaints, widens areas, changes colors, and allows his process to be visible in the final piece by allowing remnants of the changes to remain, carrying the history of his process. Perfection from the hard edged forms contrasts with subtle irregular elements. The irregularity comes from: paint drips and other remnants of Dane's process which are allowed to remain vis-

ible along the thin aluminum sides; the light brushstroke texture reveals a "hand at work;" and a surface texture is created from underlying layers where forms were moved and repainted.

Kasarian Dane
Untitled, 2009
Acrylic and Flashe on aluminum
16" × 24" (41cm × 61cm)

Other Art in This Style

- Piet Mondrian and other artists from the De Stijl or Neo-Plasticism art movement
- Color Field painters such as Kenneth Noland, Joseph Albers, Ellsworth Kelly, Kasimir Malevich, and shaped canvases of Frank Stella
- Futurist painters such as Joseph Stella
- Frederick Hammersley, Al Held, Abraham Gelbart, Keith Haring
- Minimalist Brice Marden
- Stained glass artists
- Contemporary artist Ed Mell paints realistic landscapes and florals using hard edge.

Variation 1: Unusual Canvas Shape

This elliptically shaped painting conveys a relationship between inside painted forms and the outer shaped and constructed canvas.

Dave Yust
Chromaxiologic—Inclusion VI with catenary Ogee curve
Acrylic on canvas (on 38 piece laminated wood stretcher frame)
54" × 84" (137cm × 213cm)

(Right) Variation 2: Cut Away Layers

This painting employs an unusual construction. Canvas board is cut away in a variety of shapes. The board is then placed over metal and painted glass. White areas in the image are silver metal. The glass is seen in the areas that are gray, gold, red and blue. Other colors are painted acrylic.

Harry Doolittle
Gentle Pandemonium
Acrylic on board with glass and aluminum leaf
43" × 32" (109cm × 81cm)

(Left) Variation 3: Contrast Hard Edge With Organic

A variety of high key and neutral colored forms contrast with a textural organic background. The shapes are packed into a set and unified to form a larger shape.

Anne Seidman
Untitled
Watermedia on wood
20" × 20" (51cm × 51cm)

SOFTENING HARD EDGES

Taping is a great way to get a clean hard edge between two paint colors. Taping, however, can appear mechanical, which can enhance your painting or work against it, depending on the results you want to achieve. By taping one color and hand-painting its adjacent color, the mechanical effects are softened, adding a handmade look to the edge.

Tip

To reduce seepage under the tape and ensure a very clean edge, you can apply a clear gloss acrylic gel or medium before applying the first paint color, along the tape's painting edge to seal any gaps between the tape and painting surface. This is especially helpful if your paint is thin or watery. Apply your paint color immediately over the gel/medium seal once it is dry to the touch.

Materials

- **Paints:** Any two acrylic paint colors
- **Surface:** A primed painting surface
- **Painting Tools:** Soft flat brush
- **Other:** Masking tape or clear tape

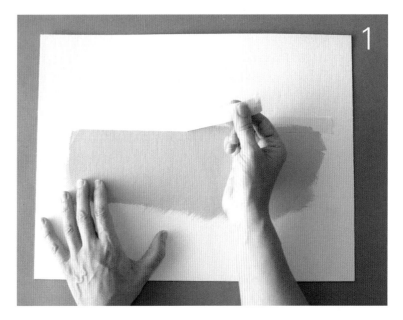

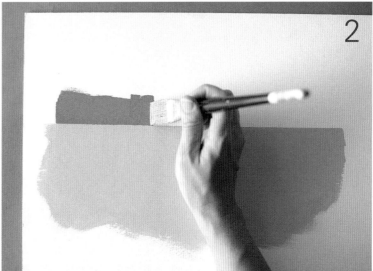

1. Tape and Paint the First Color

On a primed surface, apply tape, lining up its edge where the two colors will meet. Press the tape along the painting edge firmly.

Paint the first color, allowing the color to go over the tape. Immediately remove the tape after painting. If left on too long, the tape may be difficult to remove later. Let the paint dry.

2. Hand Apply the Second Color

Select a second acrylic paint color and load it onto a soft flat brush. Place the brush at one end and press gently, gliding alongside the previous line. Make sure you breathe while painting to relax your hand and help it move in a straight path. If your brush goes over the edge, correct it later with the first color. Go back and forth alternating with both colors until the edge looks clean.

Repeated forms or patterns in an overall "field" can produce varying spatial effects, depending on the compositional design and treatment. A flat, tight pattern can evoke a shallow space, yet the illusion of depth can be enhanced by overlapping, contrasting, movement and the treatment of negative space. Patterns are tricky elements to use in paintings. Symmetrical patterning risks producing a wallpaper effect—timidly hanging in our periphery and easily ignored. However, patterns organized into asymmetrical areas and combined with spatial effects can become vibrant and seductive.

Jim Waid's sophisticated use of aesthetics, especially contrast, transforms flat decorative patterns into a painting that presents the experience of three-dimensional space. Textural areas contrast with smoothly painted ones, reflective sheens contrast with matte, transparent colors play off opaque, and patterns mingle with solidly painted areas. Waid feels the point of his art is to create a sense of "presence" in and on the canvas. He strives for convincing space so the image becomes real, not illusion. His paintings are not illustrations, but rather enactments of the world around him.

The Artist's Process

Early in his painting career, Waid made a commitment to find something original. Along the way he passed through several distinct phases, invented many processes and techniques, even creating his own tools. Waid calls his process the "guerrilla school of technique"—using whatever it takes to get the image he wants. He rarely starts a piece knowing what it will look like and lets it develop during the act of painting. The physicality of the paint plays an important role. works wet in wet, adding colored paint directly into wet gel already on the surface, mixing it all directly on the canvas. He never uses mixing palettes. Super large kitchen spatulas are a favorite tool, along with sponges, rags, scrapers, sticks, brooms, spray guns and paint rollers.

TIPS
from the Artist

Use inspiration from the masters and others who inspire you, and combine this with ambition to create the best. Let go of academic dogma. Think with the paint, not about the paint.

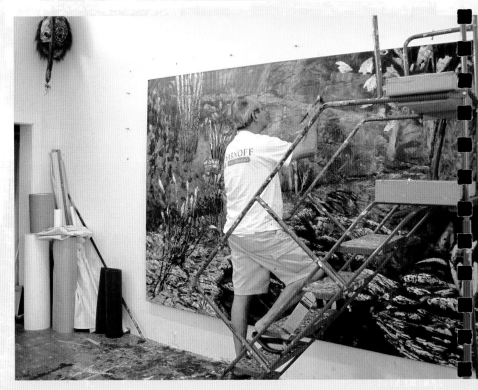

Jim Waid working large in his Arizona studio. Inspired by his desert surroundings, Waid keeps his forms and patterns hovering at the edge of recognition, and notes "The Sonoran Desert has the craziest landscapes. If the gods can use every kind of twisty thing in the world, why can't I?"

Other Art in This Style

- Wassily Kandinsky
- Modern artists Henri Matisse and Joseph Stella
- Postmodern artist David Hockney
- Decorative patterning in Gothic and early Renaissance art frescoes with Italian masters such as Giotto de Bondone (1267–1337)

Jim Waid
Evening Notes
Acrylic on canvas
79" × 61" (201cm × 155cm)

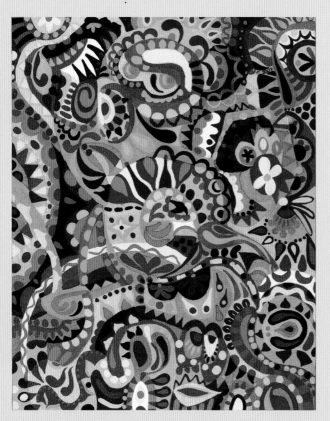

Variation 1: Combine Pattern and Sheen

Combining decorative papers with acrylic in a unique layering process produces elegant and rich imagery with a touch of whimsy. Pat Forbes creates unusual surfaces using reflective paints to add a shimmering magical sheen.

Pat Forbes
Neutrino Blossoms
Acrylic and paper on panel
Three panels, each 16" × 16" (41cm × 41cm)

More Variations

- Add decorative papers and patterned objects such as mosaics or fabric to a painting. Compare the difference between adding patterns along a border surrounding an image and adding patterns directly into the image.

- Start with patterned papers secured onto a surface as background. Use opaque paint to overpaint and eliminate some patterned areas, and transparent paint to emphasize or change others.

- Paint a realistic still life using several patterned fabrics in your setup.

Variation 2: Highly Detailed Design

Thaneeya McArdle uses meditative states and tribal sensibilities to create highly detailed designs conveying energy and flow of spirit and matter. Complementary pairs and intensely bold colors add an optical vibration.

Thaneeya McArdle
A Salutary Encounter
Acrylic on wood panel
8" × 10" (20cm × 25cm)
Private collection

GHOST IMAGERY: REVERSE PAINTING

Jim Waid has a continual desire to invent. One of his earliest processes was to paint on the back of canvas. The paint partially seeped through to the front creating a new "ghost image," offering surprising new patterns and inspiration for the painting's continued emergence.

Tip

Pretest the canvas by dripping some water onto its surface. If the droplets hold their form, the fabric needs special washing to remove any water-repellent coatings. Wash the canvas in a washing machine using warm water, adding one tablespoon each of Synthrapol and soda ash. Once any coatings are removed, place the dry canvas over protective plastic on the floor. Either side of the canvas is fine to use; however, whatever side faces up in this step will be the back of the painting later.

Materials

- **Paints:** Any acrylic paint colors
- **Surface:** Untreated, unstretched medium or heavy weight raw canvas or linen
- **Painting Tools:** A variety of painting brushes, water
- **Other:** Any liquid soap or Golden Acrylic Flow Release

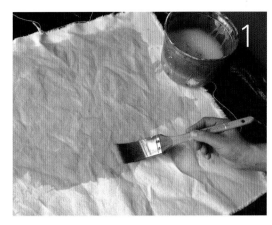

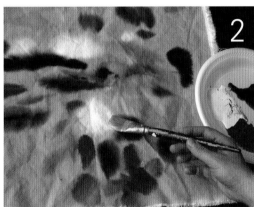

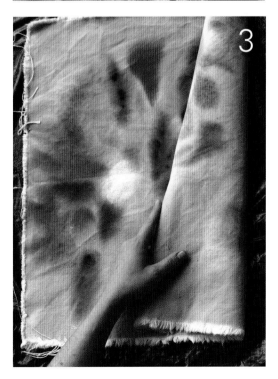

1. Apply Soap to the Reverse Side of the Canvas

Dilute liquid soap (a more refined version is Golden Acrylic Flow Release) with water using a 1:4 ratio, and generously apply onto the canvas using a large brush, or other applicator, to the entire surface. Apply enough to wet through to the other side of the canvas. Lift the canvas and remove any excess puddling from underneath or move the canvas to a dry area.

2. Apply Paint Color

While the canvas is still wet, apply paint diluted with water. Start with a 1:1 ratio of paint to water, then experiment with the amount of water to create a variety of dilutions and color intensities. Add enough water so the paint can soak through the canvas threads. Lift the painted canvas and remove excess paint from underneath or move to a dry area. Allow to dry flat.

3. Flip the Canvas to the Reverse Side

Flip the canvas over to see the results on the reverse side. The colors seep through in a variety of ways, but more subtle and softer, creating an interesting new appearance. Use this side as your painting's new front and first layer. If the front and back are identical, then try this again on a thicker piece of canvas, or use less water in the paint colors.

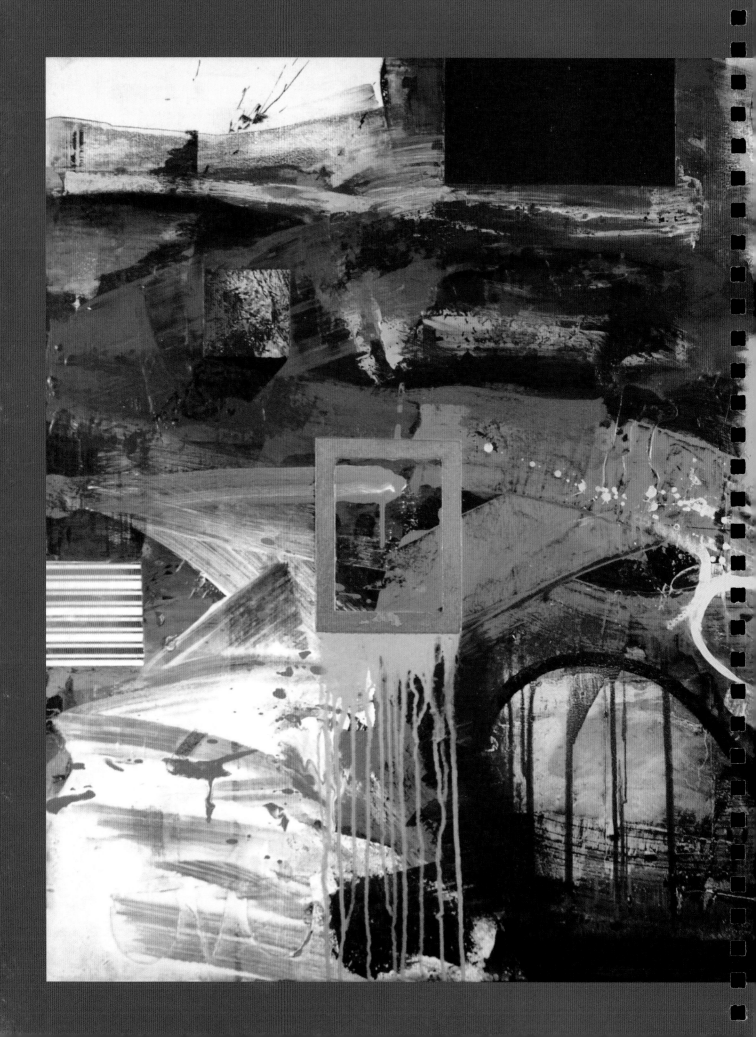

Section

SPATIAL PUSH-PULL

Renowned teacher and artist Hans Hofmann coined the phrase push-pull to describe a visual play of pictorial space—the sensation of the eye being pushed and pulled into the illusory depths of the painting's space. Here lies a signature of contemporary art, containing both directional movements, a push toward the illusory depths and a pull back toward the front picture plane, and a continued tug of war between the two. This section offers examples of nonobjective abstract imagery that make use of this effect.

Gary Denmark
Depth Charge
Acrylic on canvas
36" × 36" (91cm × 91cm)

This style has roots in the Abstract Expressionist and Surrealist movements, which focused on the subconscious and spontaneous coming through the work. Here marks carry expression, and are also key to creating the spatial qualities. Jackson Pollock's drip paintings are one example of how an artist collaborates with the material to express a gesture, creating a signature in the paint. An ambiguous shape, form or mark can appear as a Rorschach test, prodding us to find something recognizable and yet also existing as just a mark. Leah Dunaway's paintings have an emphasis on mark making and architectural space. She uses linear elements such as straight lines and corners, delineating architectural spaces. These contrast with organic marks such as squiggles and loops to create an evocative pictorial space, a "vibratory push-pull." Her paintings often involve a sheet of Plexiglas, bolted and overlayed onto the work, adding an industrial component and drama by casting shadows and enhancing the sense of space. Her work keeps evolving, each new series emerging from the previous one.

The Artist's Process

Growing up with an architect father, Dunaway learned to read blueprints and to this day is attracted to architectural forms and spaces, which she continually adds to her subconscious "file." Patterns, shadows and the play of light through forms continually interest her. Architectural elements appear naturally in her work, since her subconscious plays a main role in her process. Dunaway works on several canvases at the same time, usually working flat as opposed to on an easel, encourages drips, and creates most of her marks using charcoal and oil stick. Her agenda is to "engage in serious play" like a child, with no expectations. During her painting process she continually turns the painting around in different ways, waiting a long time to declare it finished. Artists who inspire Dunaway include Hans Hofmann, Jackson Pollock, Richard Diebenkorn and former art instructor Katherine Chang Liu (featured on page 114).

TIPS from the Artist

Continual growth will keep your work fresh. Continue to modify, change and expand what your work is about. Your whole life will feed into it. Everything you do goes into the same giant soup pot to make a chili.

Dunaway often finds inspiration in familiar surroundings such as hardware stores, where she can find small sample bottles of house paint, in decorator colors both opaque and muted, for experimenting cheaply at home.

Other Art in This Style

- German and Abstract Expressionists such as Jackson Pollock (check out his early work in addition to the drip paintings), Mark Tobey, Joan Miró, Wassily Kandinsky, Willem de Kooning, Paul Klee, Henri Michaux, László Moholy-Nagy
- Contemporary artists: Sam Scott, Agnes Martin, Vernon Fisher's "blackboard" paintings, Joan Mitchell
- The calligraphic-style scribble paintings of Cy Twombly

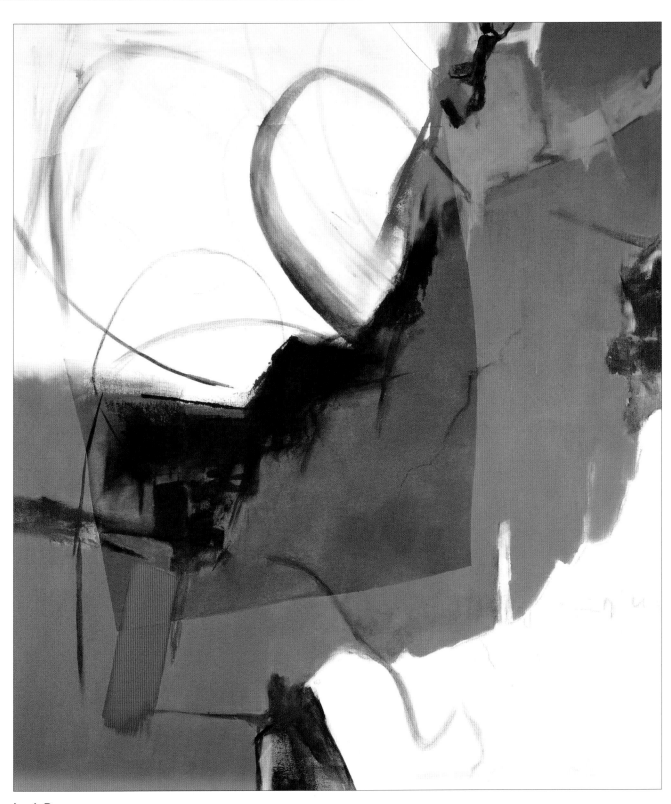

Leah Dunaway

Fusion 2

Acrylic on canvas

56" × 46" (142cm × 117cm)

VARIATIONS ON MARKING SPACE

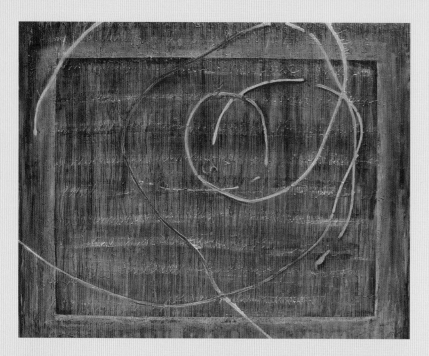

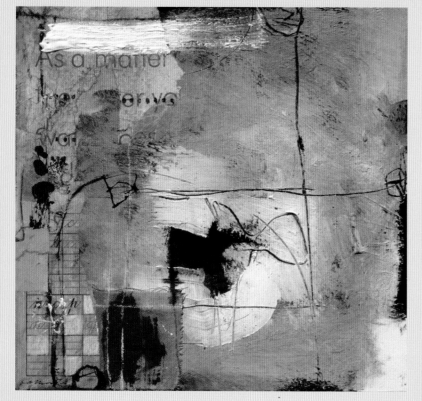

Variation 1: Contrast Marks With Background

Small vertical strokes repeat to create a background field. This emphasizes the larger lines which are curvy, bold and gestural.

Beth Ames Swartz
The Fire and the Rose: But Heard, Half-Heard, in the Stillness
Acrylic on canvas
54" × 66" (137cm × 167cm)

Variation 2: Vary Marks

A limited palette of colors contrasts with the wide variety of marks, including text, hand drawn lines, graphs and brushstrokes.

Katherine Chang Liu
Drawing #1
Acrylic and mixed media on paper
11½" × 12½" (29cm × 32cm)
Courtesy Jenkins Johnson Gallery, San Francisco and New York

More Variations

- Experiment making a variety of marks using different tools. Vary how you hold the tool, the type and consistency of paint you use, and the surfaces. Keep these experiments as reference for later ideas.

- Start with one mark on a blank canvas. Take a moment to consider what this one mark feels like. Make another mark that responds to the first, either by being similar or opposite, or keeping some qualities while changing others. Continue in this dialogue making, more marks, each one responding to the last, and noting how each new mark affects the whole image.

Jim Waid, featured in the previous chapter, likes to invent his own painting tools to obtain the marks he prefers. Here are some ideas to expand your application options.

Tip

Priming your cardboard before or after you cut the comb from it will make it more durable. Applying a coat of gloss acrylic medium over the background color will give cleaner marks and ease for the subtractive part in step 3.

Materials

- **Paints:** Any acrylic paint color different than the surface color
- **Surface:** Any primed surface pre-painted with color
- **Other:** Gloss acrylic gel, painting knife, cardboard, cutting knife

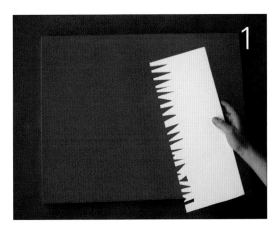

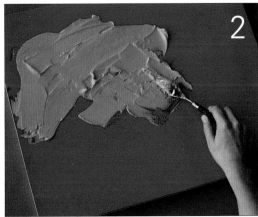

1. Cut Out a Cardboard Comb

Using thick cardboard and a sharp cutting knife, cut small triangles or wedge shapes into the cardboard, leaving a margin at the top. Vary each triangle in size and length to obtain a less predictable comb effect with the paint.

Here is a finished hand-cut cardboard comb, along with a surface pre-painted with brush-applied Pyrrole Orange.

2. Apply a Gel Layer

Select a color that contrasts with the background color. Using a knife, mix it with thick gloss gel in a 1:1 ratio. Mixing gloss gel into the paint slows the drying, allowing more working time. Generously apply the color mixture over the background. Here the blue color is made with Primary Cyan, Titanium White and Soft Gel Gloss that is then applied over the Pyrrole Orange background.

3. Create Subtractive Marks by Combing

Comb through the wet blue paint layer to "subtract" the blue while creating lines in the underlying orange color. Smooth out some areas with a painting knife, then repeat subtractive combing, moving in a different direction. Repeat as much as desired.

Other Homemade Tool Ideas

Join commercial brushes together to make an oversized brush for large strokes and marks. Consider using non-art tools for unusual marks such as kitchen spatulas and other household objects, scrapers, squeegees, combs, mops and whisk brooms. Browse through home improvement, decoration and discount stores for objects, imagining what type of mark they would make, and experiment.

Forms that are abstract or nonobjective can appear to float in space when there is no distinguishing horizon line or sense of ground. Barbara Moody's painting pictured opposite gives a feeling of being underwater or suspended in air. It is easy to see from the organic shapes in the painting that nature is an inspiration for Moody, and no surprise that she lives in a house filled with specimen jars from her incredible self-made nature collection.

The Artist's Process

Starting flat on the floor, Moody makes marks on her surface, then applies overlapping layers of paint. The marks she makes determine the content from there. Moody does not rely on reference material on hand, working mostly out of her head. She admits that years of traditional figurative painting instruction and many years of painting experience have made this viable. However, because she is accomplished at drawing and painting realistically, it would be too easy for her to copy reference material, so by keeping them out of sight she is able to make her actions more her own. She relies on accidents that can then be more deliberately worked.

Moody pushes herself into unknown places by using asymmetrical composition, or colors she finds unattractive. She mixes colors in big plastic cups in large quantities, helpful for big paintings, and never uses primary colors right out of the tube. She likes to make "nameless" colors, such as celery, peach or apricot, ones that are not as easy to identify as red or blue. Each layer has areas that are softened, quieted down by glazing, and edited, while a few select items are enhanced. Every day she sketches, and at night she goes through her journal and makes notes, often writing about conceptual ideas to get to the essence of the mood or feeling—not so much the subject. After completing a series, Moody moves on, fueling her sense of discovery and her desire to create something that has never been seen before. She feels her work has to come from within and not from an external source, representing who she is and containing a type of authenticity.

TIPS from the Artist

Work flat or on the floor instead of at an easel. Pour, scrape, use odd tools to add spontaneity. Respond to happy accidents. Feel as if you are back in kindergarten but with wise intent. Allow yourself to discriminate, edit, refine, eliminate and enhance.

Barbara Moody in her Massachusetts studio. Moody is inspired by young cutting-edge painters because they push the boundaries of painting today and have fewer preconceived habits from modernist dogma.

Other Art in This Style

Works by Joan Miró, Wassily Kandinsky, Marc Chagall, Ross Bleckner, Joan Snyder, Lee Krasner and Roberto Matta

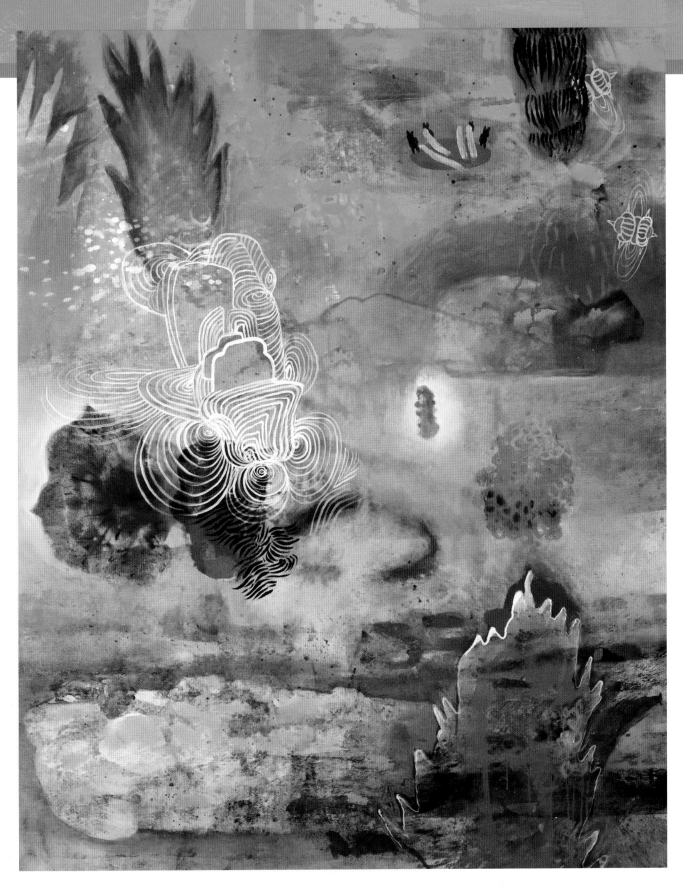

Barbara Moody
Ecosystem
Acrylic on canvas
60" × 48" (152cm × 122cm)

VARIATIONS OF FREE-FLOATING ORGANICS

Variation 1: Minimal Color Palette
Using a minimal color palette places the focus on the fluid flowing forms.

Lisa Ferguson
Escaping the chaos to a peaceful haven
Acrylic and mixed media on canvas
80" × 60" (203cm × 152cm)

(Below) Variation 2: No Horizon Line
With no recognizable horizon line to evoke a landscape, organic forms are energized in space.

Sam Scott
Blues for Charlie Parker
Acrylic on canvas
80" × 66" (203cm × 168cm)

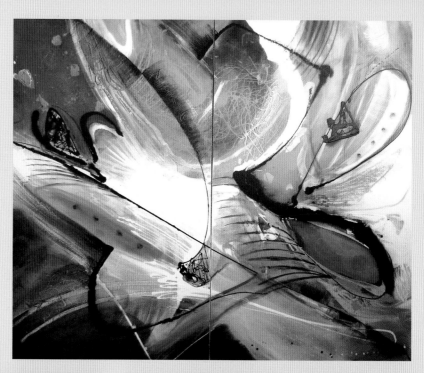

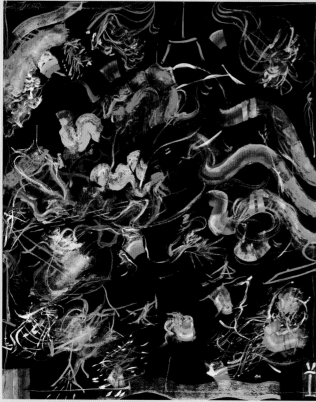

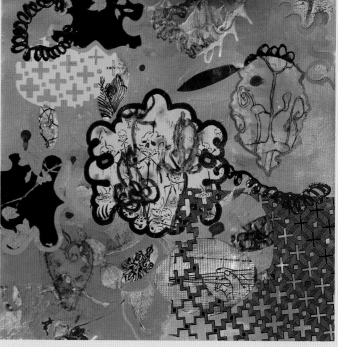

(Above) Variation 3: Variety of Patterns and Forms
A variety of patterning and forms are created through collage, stencils and ink-jet printed acrylic skins.

Patti Brady
Blue Bonkers
Acrylic on paper (with transfers and digital images)
27" × 27" (69cm × 69cm)

Gary Denmark, whose work is shown on pages 100 and 116, uses this print-making technique in his paintings to soften some of the edges of his painted forms. It's a great way to integrate hard edged geometric forms with soft, organic areas and shapes.

Tip

If you don't clean the plastic from step 2, you can save it and reuse it in a collage by cutting up the plastic and regluing it into another painting. Another recycling idea: Apply clear acrylic gel over the dry shape left on the plastic. Let dry. Peel off as a skin and use in a collage.

Materials

- **Paints:** Any acrylic paint color
- **Surface:** A primed painting surface
- **Painting Tools:** A variety of brushes
- **Other:** A clear plastic sheet

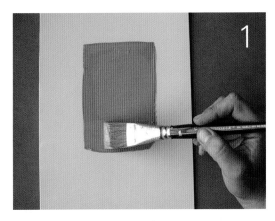

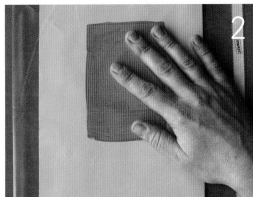

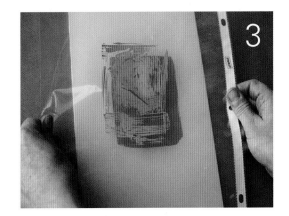

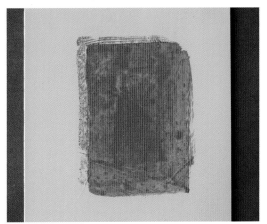

1. Paint a Shape

On a primed or pre-painted surface, brush-apply a shape. This background is painted with a light green color made from Titanium White, Turquoise Phthalo and Permanent Green, while the shape uses a pink made of Titanium White and Quinacridone Red.

2. Blot the Wet Paint

While the painted shape is wet, place a sheet of plastic over it and rub gently to pick up some excess color. This will create an imprint or light textural pattern.

3. Remove the Plastic

Carefully remove the plastic by lifting straight up. Place the plastic down again slightly off register to the original shape to create a double image along the edge. Rub to transfer the excess color onto the surface. The plastic can be cleaned and reused by wiping with a damp cloth.

Finished Example

Originally a hard edge shape, it is now softened with the addition of a ghost or double of itself slightly overlapping.

Using text in an image can create a peculiar visual play, and an enriched viewing experience. Text can be seen as symbol, sound or as a graphic, and can enhance any narrative qualities. Former graphic designer Debi Pendell learned to see areas of text as shape, color and value, and to respond to letters and words abstractly. Pendell views everything as a symbol: letters, words, trees, brushstrokes, line, color and texture, and combines these to create a readable space. At first she paints a believable reality, and then she purposely "spoils" it to change the way we view it, like placing a wrong value or odd size somewhere, or peppering her image with letters to bring attention to the front surface.

The Artist's Process

Pendell starts by building up an initial background using collaged papers, often adding painted elements. Some imagery, like the trees in *Proposed Possibility* on page 111, are her own photos turned into gel skin transfers. Pendell creates a faux encaustic (wax) appearance by applying a variety of acrylic gels ranging from very thick to very thin, both gloss and matte. The multiple layers of gel add a depth and a real physical space, underscoring the illusion of space she creates with her landscape format. The matte gels add a nice encaustic look, but often obscure the text and imagery too much, so instead she works with Golden High Solid Gel Gloss to get the thickness, followed by several final coats of matte medium on top. This adds control over how much veiling the matte acrylic

will produce. To ensure that letters are read as abstract marks, Pendell purposely spaces them apart enough to avoid having them come together as words. Pendell finds inspiration in artists such as Henri Matisse, Robert Rauschenberg, Sylvia Plimack Mangold, Giorgio Morandi, Sean Scully and Louise Bourgeois.

photo by Barry Goldstein

Debi Pendell in her Massachusetts studio..

Other Art in This Style

- Contemporary artists: Ed Rusha, Jenny Holzer, Julian Schnabel, Robert Indiana
- Asian woodcuts, especially from Buddhist texts, include poetry and writing seamlessly into the imagery
- Joseph Kosuth, Gino Severini, Barbara Kruger, Larry Rivers

Debi Pendell

Proposed Possibility

Acrylic, collage and mixed media on canvas

48" × 48" (122cm × 122cm)

Collection of Caron and Scott Palladino,

Saratoga Springs, NY

Variation 1: Enhance Painted Forms With Linear Elements

A physical three-dimensional quality is sustained by Teresa Stanley's addition of collaged paint skins and paint. Lighting grid plans with technical references were silkscreened into this image, creating a dialogue between art and science.

Teresa Stanley
Not At All
Acrylic and mixed media on wood panel
36" × 48" (91cm × 122cm)

Variation 2: Use Readable Text for Impact

Text here is kept readable as word with attention to placement and shape creating an immediate association and impact.

Bill Dunlap
Unholy Trinity
Polymer paint on canvas
49" × 37" (124cm × 94cm)
Collection of the artist

More Variations

- Experiment with balancing lines, text and imagery by changing the amount of each in a piece. Try almost all text with barely any imagery, and the reverse, mostly imagery with scant text. Change your process by starting with text then adding imagery, or the reverse.

- Explore the spacing between letters to find the amount of space needed to form words, and the distance needed for them to read as design or graphic elements.

- Use writing you find inspirational, from books, poetry or other sources, whether personal or found, and find ways of incorporating sections of the writing into your work.

Stencils are used here in an unorthodox way to create accidental marks. When used conventionally, stencils can sometimes offer imagery that is too specific to integrate, with hard edged forms and a mechanical look. This technique shows a way to use stencils that avoid the commercial cutout appearance, adding softer abstract elements by using smaller portions of the stencil design.

Materials

- **Paints:** Any acrylic paint colors
- **Surface:** Any primed painting surface
- **Painting Tools:** Painting knife with stepped handle
- **Other:** Heavy or very thick acrylic gloss gel, a plastic stencil, paper towel

1. Prepare the Materials

Select a paint color and stencil design. Tape the stencil onto a painting support with or without a background color. Make a mixture of color and acrylic gel in a 1:1 ratio. Adding thick gloss gel slows the drying, eases application and reduces leakage underneath the stencil.

2. Apply Color to the Stencil

Load a painting knife along the back side, with plenty of the paint/gel mixture. Begin by depositing the paint onto the plastic part of the stencil, not too close to the open cutout portion of the design. Press down hard with the flat side of the knife, and swipe across the stencil, allowing mistakes, missed areas and skimpy paint in some places. By pressing hard, only small portions of the design get transferred, creating unusual abstract "hand-applied" design elements.

3. Remove the Stencil

Carefully lift the stencil off to reveal fragments of the design. Repeat using different stencils and new colors to get a buildup of interesting abstract marks.

Composing with geometric shapes offers a contemporary way to create space. Katherine Chang Liu creates a delicate balance between geometric and organic shapes; color contrasts; and combinations of drawing, collage and paint. Liu's paintings result in a balance between chaotic and controlled emotional content. Her work focuses on our daily sensory overload with visual, literary, musical and verbal information. Of her work, Liu states she maps "this emotional state with autobiographical marks and a reference to the urban environment in which I live and work."

The Artist's Process

Liu gets her inspiration from words, through poetry, news articles—anything that triggers a visual possibility. She continually creates lists of words, allowing time for ideas to simmer. Around these ideas, Liu makes twenty or more thumbnail sketches for general design, overall shapes and color atmosphere. Liu also collects items, which she readily collages into her work. Working in a series, she still only focuses on one painting at a time. Each painting in the series is a comment on the last one. Surfaces are built up using a variety of materials, including acrylic, charcoal, fabric, wood, direct drawing and fragmented paint areas. Working for that true image, Lui remains unattached and continues adding and subtracting paint and layers. Sometimes this fails, but Liu doesn't try to please others; she just needs to please herself. The work needs to reflect back to her like a self-portrait or mirror. If the work comes too easily to her technically, she doesn't trust it and changes it. Questions arise for her such as: How do you cover something and still reveal it? Is it just sitting there on the surface, or worse, jumping off the page? Would slightly veiling it make it more integrated and add more mystery? Something too obvious might be improved if veiled and allowed to be discovered at a second glance. How to hold the weight of importance? How much is allowed to sit on the surface is the artist's choice.

Liu frequently curates art exhibitions and acts as juror to many competitions, keeping her current on the art scene. Artists that inspire Liu include Robert Irwin, Robert Rauschenberg, Anselm Kiefer and Joseph Cornell.

Other Art in This Style

- Hans Hofmann, Fernand Léger, Mark Rothko and other Color Field artists
- Antonio Tapies, Eva Hesse, Piet Mondrian, Jean Hélion, Wassily Kandinsky, Jasper Johns, Franz Kline, Robert Mangold
- Auguste Herbin, who developed a movement emphasizing color through geometry

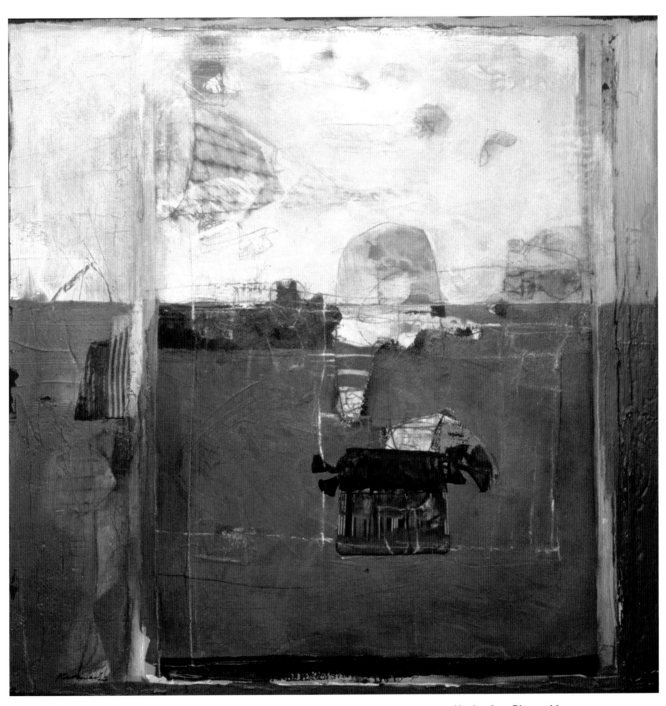

Katherine Chang Liu
Night Walk
Acrylic and mixed media on panel
30" × 30" (76cm × 76cm)
Courtesy LewAllen Contemporary Gallery,
Santa Fe, NM

Variation 1: Experimental Techniques and Surfaces

The combination of techniques and surfaces with geometry creates a unique space. Painting on old hollow core doors cut down to size, Sandra Duran Wilson first applies gold leaf to the entire surface. Heat and viscosity are used to push the medium around to create effects. Monoprints and wood block prints are cut in strong shapes then collaged, while glazing shifts colors. The circles are recurring symbols for the artist, representing overlapping dimensions of time.

Sandra Duran Wilson
The Other Side
Acrylic, gold leaf and collage on panel
40" × 48" (102cm × 122cm)
Private collection of Naresh and Kavita Nakra

Variation 2: Contrast Geometric With Organic Shapes

The bold use of geometric shapes contrasts well with gradations of color, fluid spaces and organic forms.

Gary Denmark
Jongleur 2
Acrylic on canvas
48" × 48" (122cm × 122cm)

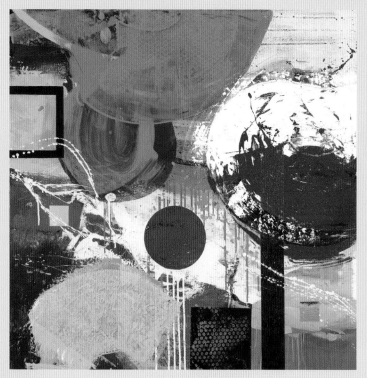

More Variations

- Collect a variety of dispensable items such as smooth and textured papers and old paintings you no longer care for. Cut out different geometric shapes in a variety of sizes and in a range of colors. Arrange these on different painting surfaces to see how they change the painting. Rearrange the items to see how the spaces between the shapes change the idea of space in the painting.

- Find a painting you admire. Overlay tracing paper and trace the large shapes created by elements in the painting. Create a new painting using these large shapes. Try rearranging them, overlapping them differently and adding your own imagery.

Liu does not get too attached to any part of the painting while working. Favored elements frequently present problems by inhibiting continued progress. Liu often uses materials that are precious and has ways of avoiding this attachment "trap." Try this project below to test your unattachment skills.

1. Glue the Collage Item

Using a surface that is much bigger than your collage item (could be a new surface or a painting already started), find a placement for the collage item with ample space around it for adding paint later. Glue the item securely in place using an acrylic gel. Here lies the big trick to avoiding attachment syndrome—making a commitment by permanently gluing the object to the surface.

2. Mix Up a Variety of Opaque and Transparent Colors

For opacity, choose mineral (inorganic) pigments such as Cadmiums and Titanium White. Transparent pigments can be made opaque by using them thick, straight out of the container or by adding white. For transparent colors, choose modern (organic) pigments such as Phthalos and Quinacridones. Opaque pigments can be made transparent by adding large amounts of gloss mediums, or by applying thinly. Pre-mix a few colors that match the background of your painting and also of the collaged item. Match colors 10 percent lighter than desired, since acrylic appears lighter when wet.

3. Apply Varying Degrees of Coverage

Apply pre-mixed colors over the collage item and onto the painting surface. Obtain various degrees of coverage by heavily applying the paint using a knife in some areas, and by applying lighter applications with a brush or rag in others. Scrape off paint using a knife in some places to add even more variety.

Tip

If your collage item is thin, like tissue paper, a thick acrylic (gel) offers a better choice for a glue than a thin acrylic (medium) and will reduce wrinkling. Use a matte gel if the glue will seep through the collage material, otherwise a gloss gel is best.

Materials

- **Paints:** A variety of opaque and transparent acrylic paint colors
- **Surface:** Any sturdy surface
- **Painting Tools:** Favorite painting brushes, knives, rags, a mixing palette
- **Other:** Any collage item you like (paper, photographs, fabric, objects, drawings), acrylic gloss gel

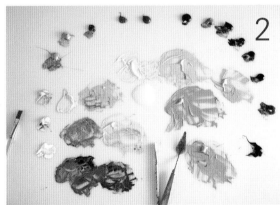

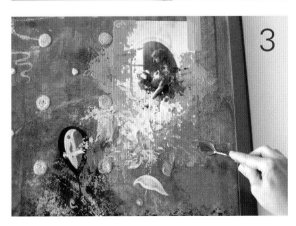

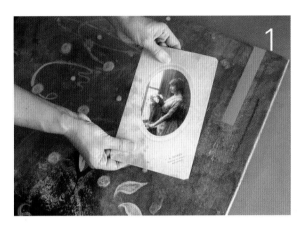

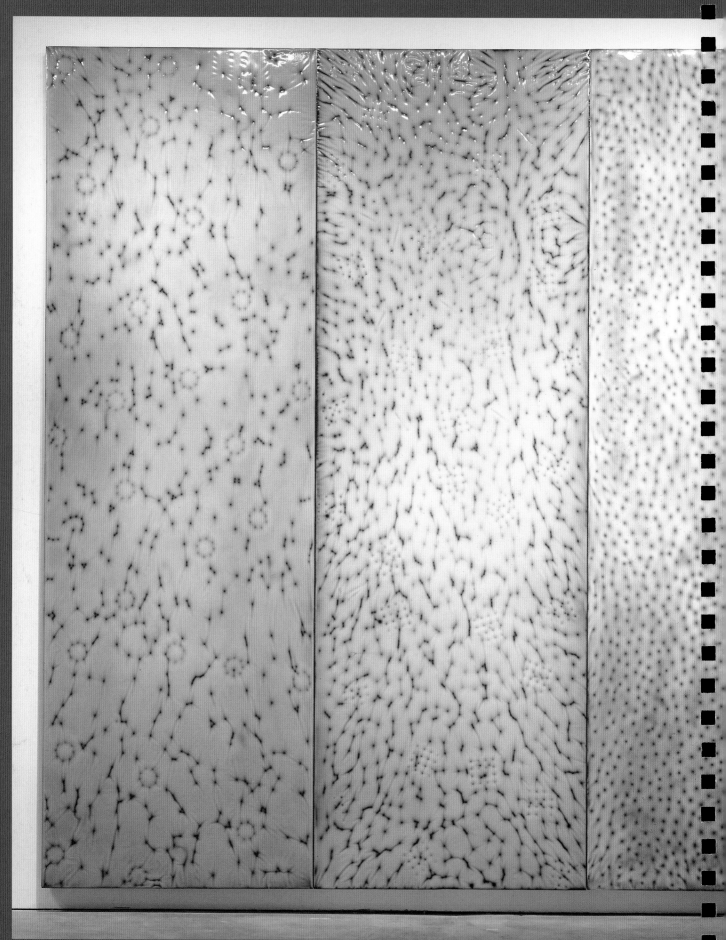

Section **6**

MINIMAL

Minimalism presents exciting challenges for both the artist and the viewer. By limiting or eliminating representative imagery, the artist works solely with aesthetic aspects to create work that attracts. A painter's aesthetic tool box consists of color, line, shape, plane, space, surface and light. These tools in themselves carry associative and narrative connections. In this section, styles use a minimum of aesthetic aspects to get maximum impact, usually evoking a meditative mood or an altered state or reality, allowing viewers to lose themselves in the purely visual.

Paul Sarkisian
Untitled (black mark/amber/vertical3)
Resin epoxy on wood
12' × 12' (366cm × 366cm)
Photo by Eric Swanson

Using sheens and texture places the focus on the painting's surface and can create a seductive tactile experience. *Canyon and Poem* (page 121) combines metal leaf with acrylic paint. This combination presents an interesting challenge for me, as the metal leaf changes qualities like a chameleon. As available light shifts throughout the day, the metallic changes from a dark value to light, and from bright to dull. Realizing that busy imagery and bold color can overpower the reflective qualities of the metal leaf, I researched historic Asian landscapes and their expert use of minimal forms and color. A play with opposites adds a sense of space in the painting, with areas containing both high and low refractive qualities, smooth and textured areas, and warm and cool glazing on the metal leaf.

The Artist's Process

Experimentation is my main painting tool. I keep playing around until I discover something new that takes me over. I allow my techniques, processes and materials to change according to the needs of each series, allowing the idea to best come through the work. Inventing the way I paint is just as exciting to me as what I paint. For *Canyon and Poem*, metal leaf is applied onto smooth panels then overpainted with acrylic. I get inspired by artists such as Anselm Kiefer, Wassily Kandinsky, Damien Hirst, and not surprisingly, many of the artists I interviewed for this book. Other ideas come from a continual searching for things I find beautiful, whether natural or man-made: fabrics, butterfly wings, cityscapes, mountains, skies, oceans and people. I draw from models once a week to keep my drawing skills alive, and continually enjoy visiting artists' studios, galleries and museums.

Other Art in This Style

- Chinese landscape paintings from about AD 900–1600
- Illuminated manuscripts from the Middle Ages into the Renaissance period
- Gustav Klimt's (1862–1918) use of metal leaf as backgrounds for sensuously painted figures

TIPS from the Artist

Don't take action on every idea that comes to you. Keep a journal to write down ideas as they come, allowing them to percolate until the right one really fuels you. Then take action. Inspired action tells you the next step. Time, experimenting and experiences bring artists to their personal vision. The inspiration for our unique vision is already in us, making it difficult for anyone to copy what we do successfully. Do what comes naturally, but make the time to create and the bravery to make things you might not have seen before. Workshops and classes are helpful, but take long periods or enough time in between to work in the studio and let the new tools and techniques simmer into your own stew.

photo by Reynaldo Villalobos

Nancy Reyner in her Santa Fe studio at work on her metal leaf paintings.

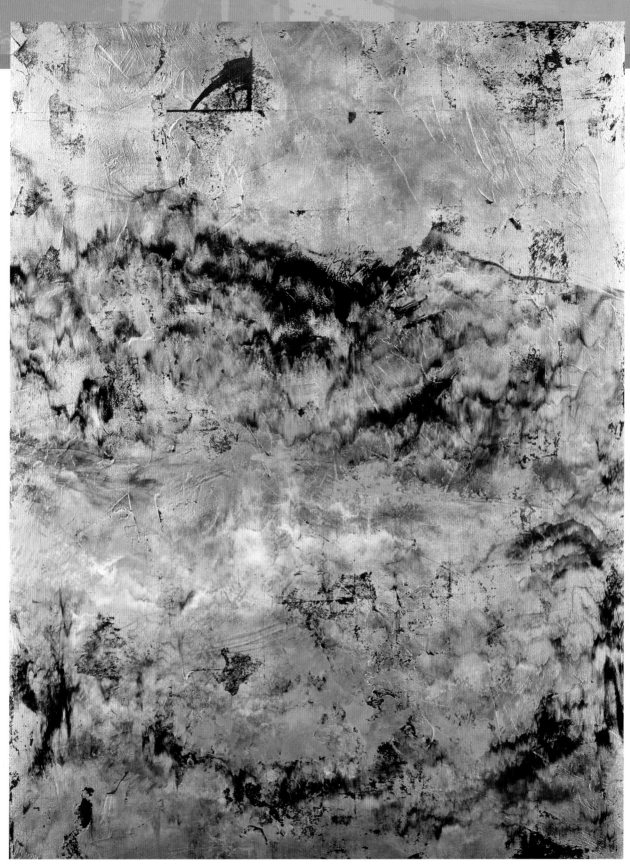

Nancy Reyner
Canyon and Poem
Acrylic and gold leaf on panel
48" × 36" (122cm × 91cm)
Private collection

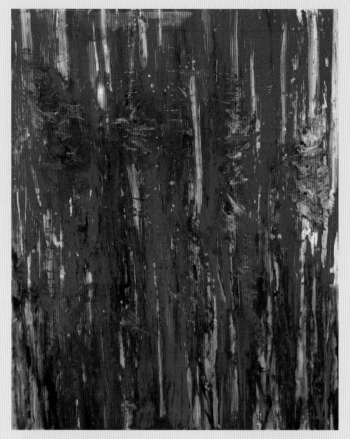

Variation 1: Create a Glasslike Surface with Resin

Clear layers of resin are applied in between colored layers, generating a glasslike surface with embedded textural effects. An aluminum surface is allowed to reflect through multiple transparent layers.

Bette Ridgeway
It Was a Rainy Red Autumn
Acrylic with resin on aluminum
32" × 24" (81cm × 61cm)

Variation 2: Textured, Monochromatic Palette

A monochromatic palette places focus on textures and sheens. The texture here is actually only visual, with no relief or physical texture. The effect is created by allowing paint to seep under previously taped areas, creating a thin but dramatic variation in darks and lights.

Reynaldo Villalobos
Redemption 1
Acrylic on panel
60" × 48" (152cm × 122cm)

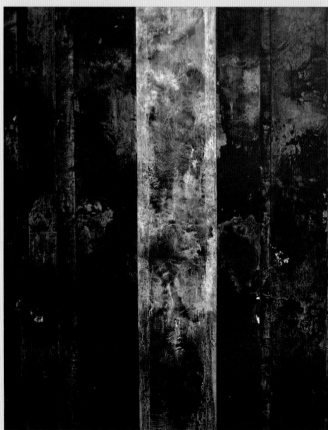

More Variations

- Create a textured ground or surface under metal leaf by first applying thick acrylic pastes or gels and letting it dry before applying the leaf. The leaf will then emphasize this underlying texture.

- Create a collage using materials with a variety of sheens and textures.

Metal leaf is an appealing material to use. There is a noticeable difference in the refraction between metal leaf and metallic paints. By contrasting them together in the same painting an interesting result can be obtained.

Tip

Use imitation gold leaf with a waterbased adhesive to avoid tarnishing. When using paint color, avoid reducing the reflective quality of the metal leaf by using modern (organic) pigmented paints like Phthalos and Quinacridones instead of the mineral (inorganic) paints like Cadmiums, which are opaque. Avoid matte or satin acrylic products as they will reduce the leaf's reflective qualities.

Materials

- **Paints:** A variety of metallic acrylic paints (copper, gold, bronze, silver)
- **Surface:** Any painting support
- **Painting Tools:** Soft flat or foam brush, painting knife
- **Other:** Metal leaf, leafing adhesive, mixing palette, gloss acrylic gel, mineral spirits-based acrylic varnish in spray or jar

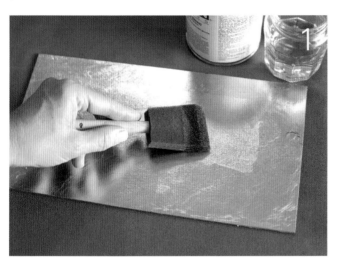

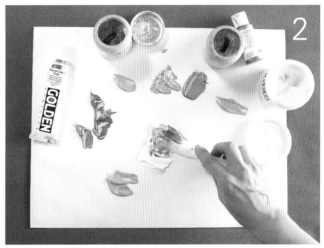

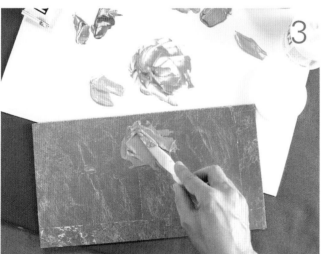

1. Seal the Metal Leaf
Apply metal leaf on a support using leaf adhesive and following directions on the product's label. Overpaint or spray the leaf with a mineral spirits-based acrylic and let dry. This coating will ensure good adhesion for any subsequent acrylic paint layers.

2. Create a Variety of Metallic Mixtures
Using a variety of metallic acrylic paints (i.e., copper, bronze, gold, silver, etc.), mix them together in various combinations to create new metallic colors. As an option, add clear gloss acrylic gels into the paint to add texture.

3. Overpaint the Metal Leaf
Apply the various metallic paint mixtures over selected areas of the metallic leaf surface. Use a brush or knife, and apply thinly for a smooth application or thickly to create texture. Avoid covering the leaf surface completely so the leaf can be seen along with the paint. Metallic paint will result in a satin finish as compared to the leaf's highly reflective sheen.

As an alternative in this step, substitute thinly applied transparent glazes of color to subtly shift the metallic leaf instead of overpainting with the metallic paints.

Illumination or the representation of light in a painting can be conveyed both figuratively or literally. Light has always played an essential role for painters. Chiaroscuro, developed in the Renaissance, uses paint to create dramatic lights and dark shadows indicating a strong light source and adding depth and mystery to the image. Contemporary artists such as Dan Flavin create art using actual light as the medium itself. Stained glass, photography and light projections are all art forms that use actual or physical light sources in the final art.

Paul Sarkisian's art career spans an astonishing range. Sarkisian continually invents and reinvents to create works that allow us to question our perception of reality. *Untitled (bronze/green42)* (page 125) is from a series of three hundred works by Sarkisian and uses contoured surfaces and pearlescent pigment to create a surface that color-shifts from different viewing angles and in different light. Sarkisian sees them as fields of energy, greatly affected by their placement in space.

The Artist's Process

Sarkisian's favorite tool is his creative thoughts. He thinks of how to make his idea in its purest form, resulting in a wide range of mediums, styles and processes. Works are created using tools such as airbrush, trowel and brush and in modes such as collage, photography, photorealism and minimalist abstraction, with mediums including acrylic, oil, asphalt, tar, gouache, gypsum, resin and foam. What he does with the technology he chooses is very important to him. In general, Sarkisian works on one piece at a time within a series.

TIPS
from the Artist

Lots of people are afraid to use their talents, and are intimidated by the art scene and superstars. If you have talent, why not use it?

photo by Dana Waldon

Paul Sarkisian in his studio, in front of one of his paintings.

Other Art in This Style

Works using real light sources by artists such as Dan Flavin, Olafur Eliasson, James Turrell, Waltraut Cooper, Aleksandra Stratimirovic and Austine Wood Comarow.

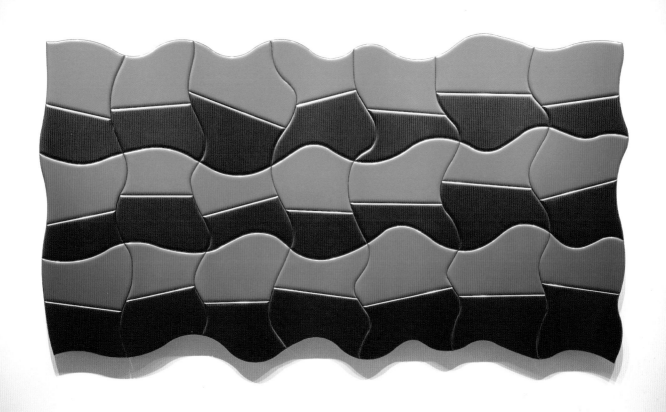

Detail

Paul Sarkisian

Untitled (bronze/green42)
Polymer resin and automotive enamel on wood
6'5" × 11'8" (196cm × 336cm)
Photo by Eric Swanson

Variation 1: A Rich Value Range in a Single Color

The use of a monochromatic palette places emphasis on the rich value range and feeling of illumination from within the painting's depths.

Sandy Keller
Lapis
Acrylic on panel
24" × 36" (61cm × 91cm)

Variation 2: Colorful Layers Over an Aluminum Surface

Resin layers over an aluminum surface creates refraction and illumination. The image itself, although minimal in forms, parallels this light idea by subtly referring to a moonlit landscape.

Bette Ridgeway
Yellow Moon
Acrylic with resin on aluminum
30" × 24" (76cm × 61cm)

More Variations

- Find different lighting situations and paint, photograph or draw these to capture their mood and feeling.
- Notice shadows and patterns created from the sun and other light sources and use these for painting inspirations.
- Create a still life using one light source. Paint the dark cast shadows and highlighted areas to capture the feel of light on the objects.

ILLUMINATED POURING

This technique takes advantage of two categories of reflective paints: Iridescent and Interference. Both can be used singly or in combinations to create new, unusual, contemporary illuminated effects. This technique uses Iridescent in the background and Interference in a transparent overpour. Alternatively, the addition of color to this technique will create a vast array of possibilities. Some helpful tips and definitions before starting:

• **Rigid surface:** Pouring is easiest when done over a rigid, sturdy support such as panel or wood.

• **Reflective Mixtures:** Adding any Iridescent or Interference to a clear medium or gel will make a reflective mixture. Adding a small amount of black to interference enhances

its color. If adding color, use small amounts to keep the color transparent.

• **Pourable Mediums:** Any acrylic medium that will dry clear and glossy and readily pours from its

container can be used in a pour technique. Thin the medium with up to 20 percent water or use specialty pouring products like Golden's GAC 800 or commercial resins.

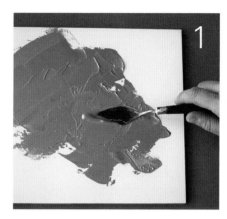

1. Paint the Background with Reflective Paint

Using a brush or knife, apply any Iridescent and/or Interference paint in any combination to create a reflective background. Here Iridescent Silver (fine) is knife-applied. Let the background dry fully.

2. Add Black Washes

With a brush, add enough clean water to the entire surface to create puddles. On a separate palette, mix black acrylic paint with water in a 1:10 ratio. Apply this black wash to the surface puddles. Let dry naturally, and the black washes will form small irregular shapes and patterns. These dark shapes help enhance the pour you will do in Step 3.

3. Pour a Transparent Reflective Mixture

Create a reflective mixture by adding any reflective paint to a pourable medium in a 1:10 ratio to maintain transparency. (Pictured here is 9 parts Clear Tar Gel with 1 part water and 5 drops each of Interference Blue, Interference Violet and Interference Red.) Lightly stir, then pour the mixture over the entire surface. Mist lightly with isopropyl alcohol. Let dry flat. Repeat Steps 2 and 3 as much as desired, letting each layer dry before adding another.

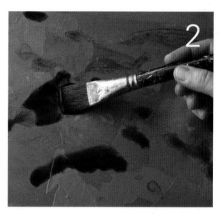

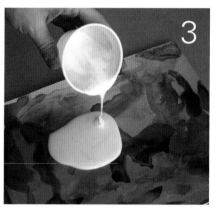

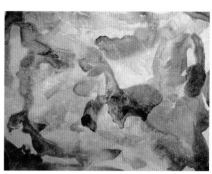

Finished Example

Materials

- **Paints:** Several Iridescent and Interference paints (optional addition: any transparent modern paint color)

- **Surface:** Any rigid or sturdy paint surface

- **Painting Tools:** Any brush or other painting application tool, plastic mixing container and stirrer, wide flat spreading tool or knife, mixing palette

- **Other:** A pourable acrylic medium, household spray bottle, isopropyl alcohol, water

Emerging out of New York City in the 1940s and 1950s, Color Field paintings generally consist of large unbroken areas of pure color, often creating an emotional or expressive field, with minimal attention to brushstroke, texture and forms. Aleta Pippin's desire to experiment and work with color as her primary tool is readily visible in her work, and her choice of working minimally allows an internal viewing.

The Artist's Process

Pippin does not like to over-plan. She usually starts by pouring a color onto the surface, setting up spontaneous events or color combinations and continuing until she finds something beautiful. She then decides to enhance, add or change areas to bring visual depth and light to the color. Pippin chooses application techniques that minimize the brush mark. She finds the color richer when applied with a knife. Applied thinly, the knife allows the paint to overlay without affecting the bottom layers, easing a building up of paint layers. Pippin continually revisits and reevaluates what she is doing and why she is doing it. She is not afraid to take a different direction and try something new, realizing each new path has a learning curve, requiring a sense of bravery to allow the feeling of being a beginner again. Early in her career Pippin was inspired by Wassily Kandinsky, Willem de Kooning and Georgia O'Keeffe. Now she is more influenced by artists such as Gustav Klimt and Helen Frankenthaler. Additional inspiration comes from listening to music from Pink Floyd to George Gershwin.

TIPS from the Artist

Believe in what you're doing. Be focused and don't listen to what others say. Artists are entrepreneurs—don't buy into the starving artist myth. Learn basic business skills to get started.

Aleta Pippin at work in her Santa Fe studio.

Other Art in This Style

- Pioneering Color Field painters: Mark Rothko, Helen Frankenthaler, Clyfford Still, Robert Motherwell, Barnett Newman, Hans Hofmann, Ad Reinhardt, Sam Francis, Anselm Kiefer
- Pat Steir's waterfall paintings

Aleta Pippin
The Fabric of Life #4
Acrylic on Yupo paper mounted on panel
8" × 8" (20cm × 20cm)
Collection of Patti and Bill Nash

Variation 1: Minimize Forms

This strong unified color field contains a range of color in softly integrated formless areas. The image verges on becoming recognizable as water or reflections.

Robin Sierra
Aquamarine
Acrylic on canvas
25" × 27" (64cm × 69cm)
Collection of Anton Lengmueller

Variation 2: Flowing Areas

A bold use of flowing forms creates movement, light and pattern within a strong field of color. "It is always about color and creating that magic moment when two or more colors vibrate against each other. That compelling force draws the viewer in, perhaps evoking a memory of a transient moment once seen," says Keller.

Sandy Keller
Time Lapse
Acrylic on panel
48" × 36" (122cm × 91cm)

More Variations

- Collect pieces of pure color (without recognizable forms to distract attraction) by ripping pieces of magazine pictures and collecting chips from paint stores and swatches of fabric. Remake these colors in paint form and build them up in paint layers to enhance the color's richness.

- Minimize the forms from an image you like by only painting its colors and shapes, and avoiding any detail. Then remove your original reference from view to continue painting. Merge and blend shapes into each other by softening edges to create an overall field of color.

COLOR ENHANCEMENT

When color is applied in several layers, the pigment takes on a richer quality. With multiple layers, light is able to refract in more complex ways, enhancing color and surface quality. Here is a technique using three layers to enhance color quality without changing hue.

Tip

This technique works best when each step uses very transparent layers. For the pour mixture in step 3 it is important to use very little paint color and/or keep application thin.

Materials

- **Paints:** Any acrylic color in several variants of its hue
- **Surface:** Any rigid absorbent surface
- **Painting Tools:** Soft flat blending brush, mixing palette
- **Other:** Acrylic Glazing Medium or other slow drying medium, household spray bottle, mixing cup, mixing stick, palette knife, isopropyl alcohol, water

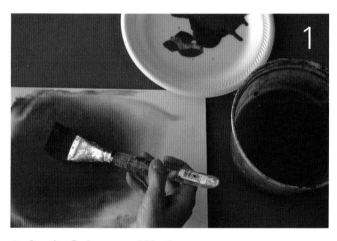

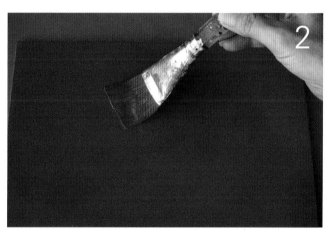

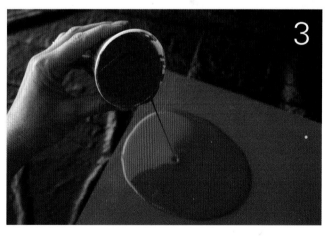

1. Apply Color as a Wash

Start with an absorbent painting surface, or make it absorbent by applying an absorbent product on first as a ground. A surface merely primed with gesso will not be as effective. Products that make good absorbent grounds will dry matte with a discernible tooth or texture, such as acrylic pastes, matte gels or gels with added materials like pumice. Alternatively, you can adhere watercolor paper to your painting surface.

Once you've attained an absorbent surface, select a color and heavily dilute the acrylic paint with water in a 1:5 ratio. Apply this color wash using a soft, wide, flat brush over the entire surface. Here Cadmium Red Medium Hue, properly diluted with water, is applied over a panel prepared with Golden's Acrylic Ground for Pastel. Let the surface dry. Repeat this step if more color is desired using less water in the wash mixtures.

2. Apply the Color as a Glaze

Using the same color from the prior step, or a variant of the same hue, combine color to gloss medium in a 1:10 ratio without adding any water. Optimally, use a slow-dry medium for this mixture to make glazing easier. Here, Primary Magenta is mixed with Acrylic Glazing Liquid and evenly brush-applied over the dried surface from the previous step. Let dry.

3. Pour the Color

Raise the painting surface off your work table with jars or other objects for support and place on plastic. Add the same color as before, or a variant of the same hue into a pourable gloss medium in a 1:20 ratio. Optionally, add up to 20 percent water if the medium is thick. Here Pyrrole Red is mixed with GAC 800 (no water is needed with this Golden product). Pour this mixture in a puddle in the center of the surface. Gently spread the mixture outward toward the corners and edges with a wide knife. Immediately spray the surface lightly with isopropyl alcohol in a household sprayer to remove any bubbles. Keep level while drying.

A dramatic visual impact can be obtained by presenting one strong form against a minimal field of color. This is readily seen in Jim Alford's painting *Confluence*. A hard edged circle placed against a soft background allows the illusion of floating. Jim Alford aligns with Minimalist philosophies, in particular with the difference between gazing at a painting and staring at it in a conventional Western way. Alford's intent is to offer a meditative experience for the viewer. Interestingly, Alford has his own mind-altering experience in the painting process. Alford typically paints using an airbrush. As he works on layer after layer, he progressively steps back with the sprayer farther and farther from the work, in a rhythmic movement similar to Tai Chi, often placing Alford in a meditative state as well.

The Artist's Process

Alford's work spans an impressive range from super-realistic to minimal abstraction. This diversity mandates an equal range in techniques and processes. Alford often begins his paintings on the computer, experimenting with colors and shapes, sometimes constructing an image with combinations of several photographs he has taken. Once he finds an image he likes, he takes it to his studio, transferring the idea into paint. Acrylic is his choice for spraying, which is less toxic than oil. Alford finds his inspiration in nature and landscape, walking along California beaches looking at the sun reflecting in the ocean, and in horizon lines and figures silhouetted against dark skies. Artists inspiring to him include Larry Rivers, Richard Diebenkorn, Mark Rothko, James Terrell, and contemporary landscape painters such as Robert Workman, Peter Nisbet and Doug West.

TIPS
from the Artist

Every artist has to find his voice and it takes a long time. Graduate school is one way to assist this process, especially by selecting teachers who allow freedom.

photo by Reynaldo Villalobos

Jim Alford's studio view offers a continual reminder of nature and landscape.

Other Art in This Style

Works by Morris Louis, Barnett Newman's zip paintings, Yves Klein, Agnes Martin and Susan Rothenberg

Jim Alford
Confluence
Acrylic on canvas
60" x 48" (152cm x 122cm)

Variation 2: A Bold Singular Form

Racing stripes are graphically illuminated with fluorescent paint and emphasized on a solid black background.

Grant Wiggins
Spaceloop Two
Acrylic on canvas
30" × 30" (76cm × 76cm)
Collection of the artist

Variation 1: A Subtle, Singular Form

A textural field supports a subtle, singular emerging form, a cross, in the upper right through the use of acrylic pastes and gels and a variety of mark-making tools.

Steve Stone
Nol
Acrylic on canvas
60" × 36" (152cm × 91cm)
Private collection

More Variations

- Select some favorite forms including geometric, organic, realistic and abstract. Draw or cut them out of colored paper. Arrange each one on different surfaces as backgrounds using paintings, tiles, fabric, wallpaper, etc. Use these as a model for creating a painting from scratch.

- Experiment with materials and techniques to create an overall background or field of color containing some accidental marks or forms. Select one of these accidental forms and make it more visible with painting techniques such as increasing the color hue or intensity, making it lighter or brighter, sharpening the edges and/or blurring or softening everything around it.

TEXTURE WITH MESH TAPE

A subtly textured background can add visual appeal to a minimal abstraction. The grid pattern of dry wall mesh tape creates an interesting effect when used in this two-layer technique using paste and washes.

Tip

Eliminate step 3 by substituting thick acrylic paint color for the paste in step 2.

Materials

- **Paints:** Several acrylic paint colors
- **Surface:** A primed or pre-painted surface
- **Painting Tools:** Any brush, painting knife or other applicator tool
- **Other:** Drywall self-adhesive mesh tape, absorbent acrylic paste, scissors

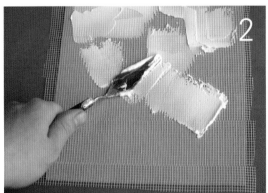

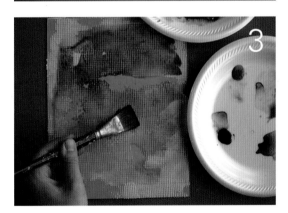

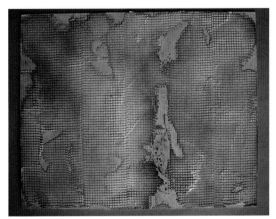

Finished Example

1. Attach Drywall Tape

On a dry surface, pre-painted with a background color, apply strips of drywall mesh tape. Press firmly to stick the tape to the surface. The background color pictured here is a mixture of Titanium White and Primary Blue.

2. Apply Paste

Generously load an acrylic paste that is absorbent or dries matte to the back of a painting knife (Light Molding Paste is shown here). Apply the paste over the tape using medium pressure. For variety, allow some areas of the tape to remain without any paste. Remove the tape and allow paste to dry at least a few hours or overnight.

3. Overpaint With Washes

Dilute each of several acrylic paint colors with water in a 1:5 ratio to create several wash colors. You can also pre-wet the dry paste surface with water in some areas to increase a bleed effect. Brush-apply the diluted colored washes separately over the paste, varying colors in areas. Blot with paper towel in some areas to lighten. Pictured here are washes using Phthalo Blue, Carbon Black, Dioxazine Purple, Anthraquinone Blue, Phthalo Turquoise, Quinacridone Burnt Orange and Nickel Azo Yellow.

VEILING FORMS

A veil is something that hides yet reveals. Veiling in painting happens when a transparent or translucent layer is applied over another layer, partially hiding what's underneath. Veiling can soften a focus, shape or edge. It can create a misty atmospheric space or add a surface quality similar to encaustic or wax. Veiling adds a sense of mystery in the act of partially hiding things. Bonnie Teitelbaum's paintings use multiple layers, building one on top of another, veiling forms and color areas to create fluid fields. Teitelbaum feels veiling adds more dimension, simulating nature, while flat applications of color feel more inorganic. Her paintings often evoke distilled ecosystems.

The Artist's Process

Meditative processing is a key part of Teitelbaum's painting process. She starts her day painting early in the morning to take advantage of feeling centered. Teitelbaum sees painting as a collaboration between herself and the chemistry of the paint, noting that she needs to put in a certain amount of paint and time to get the image to a certain point. First she experiments to see what happens, often discovering new and unusual forms. These accidental discoveries then get developed further with more paint. She frequently applies gels over the painting in stages between layers. Gels are mixed with color, then poured on top of other layers. While the gels are still wet, she adds more color and manipulates the work.

> ⊙ **TIPS** from the Artist
>
> It's good to discover new tools. Abstraction relies on experimentation and discovery. Education is also important, learning about the characteristics of paint and materials.

photo by Reynaldo Villalobos

Teitelbaum gets inspiration out in nature, offering her peace of mind, and which she intends to convey through her work. Teitelbaum is inspired by James Abbott McNeil Whistler's reduction of elements to distill a landscape. She is also inspired by Vincent Van Gogh for movement, brushwork and color.

Other Art in This Style

- The painted forms of Joseph Mallord William Turner (1775–1851) that dissolve into atmosphere
- The evocative, moody works of James Abbott McNeill Whistler's (1834–1903) *Nocturnes* series
- Abstract Expressionist painters Morris Louis and Helen Frankenthaler

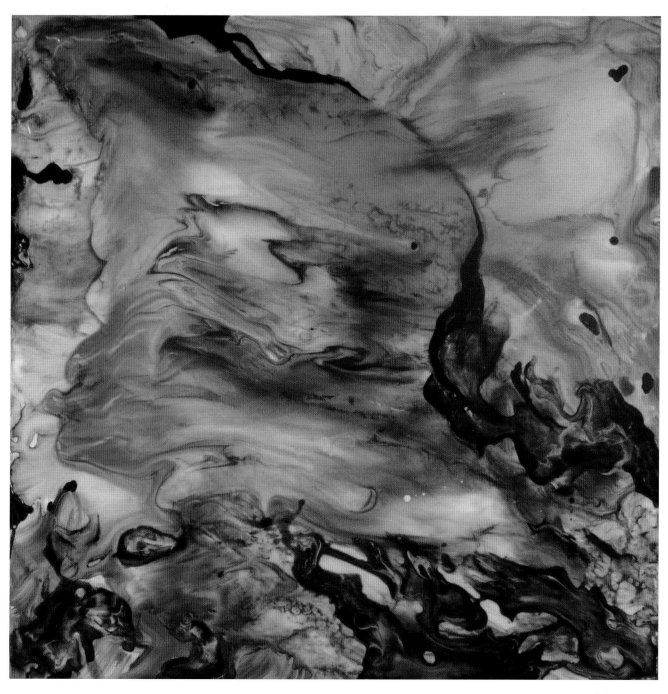

Bonnie Teitelbaum
Tidal Flow
Acrylic on panel
24" × 24" (61cm × 61cm)

Variations: Neutral Colors and Obscured Forms

These paintings by Doug Trump represent excellent examples of veiling. Trump uses neutral colors plus obscured forms to create a sense of mystery, allusiveness and space. For Trump a painting is a demonstration of its history. He works it until it breathes on its own.

Doug Trump
Breezeway
Mixed media on polymesh
21" × 33" (53cm × 84cm)

Doug Trump
Tiptoe
Mixed media on paper
32" × 40" (81cm × 102cm)

More Variations

- While creating a painting, place pieces of tissue paper over areas without attaching them just to see how veiling will change its appearance. When you find a place where veiling improves the work, apply the tissue permanently using acrylic as glue, or apply layers of matte gel, or transparent applications of colored paint.

- Dry-brushing or using thin layers of paint can also produce translucent layers of color that can act as veils. Try finding several ways of applying a layer of color on top of another without being so opaque that it completely hides the underlayer.

EMBEDDING PAINTED FORMS

An intriguing spatial depth can be created when paint is embedded in transparent layers of acrylic. You can create some interesting options and effects with this technique.

Tips

- Use a matte gel for this technique to create an encaustic or waxy look.
- Gloss will give the most clarity, while matte or satin will give a frosted or veiled appearance. Try varying the types of gel each time you repeat Step 1 for a new layer.

Materials

- **Paints:** A variety of acrylic paint colors
- **Surface:** A nonstick surface for acrylic such as freezer paper, HDPE plastic or garbage bags
- **Painting Tools:** Palette knife or spatula, brush
- **Other:** Acrylic gel (matte, satin or gloss)

1. Apply Gel to a Non-Stick Surface

Select an acrylic gel. Using a wide spatula, apply gel onto a nonstick surface in a thick layer, at least ¹/₈-inch (3mm) thick. Work with the knife to get the surface fairly smooth.

It's your choice to continue to the next step while the gel is still wet, or to wait until it's dry. Each option will produce different results. Experiment both ways to find your preference.

2. Apply Paint Color

Select several acrylic paint colors using a range of hues and transparencies. Add water to each of the paint colors. Start with a 1:1 ratio, then create variety by adding more water to increase the transparency, and less to increase the opacity. Apply paint to the top surface of the wet or dry gel using a brush or knife. If desired, spray water over the paint before it dries to get softer edges and blurred forms. Let dry on a level surface.

3. See the Reverse Side

The gel should dry for at least a day or more until the white of the acrylic has turned clear. Peel the gel off the surface. Note its reverse side is smoother and the painted forms appear embedded. This "skin," or unattached piece of painted gel, can now be glued onto a background with either side facing up.

Alternative for Step 3

Before securing the skin onto a background, repeat the first two steps to create more skin layers. Combine skins one on top of the other, attaching them by gluing with more gel.

CONTRIBUTING ARTISTS

Jim Alford
www.jimalford.com
New Mexico

Hamish Allan
www.hamishallan.co.nz
Christchurch, New Zealand

Daniel Barkley
www.danielbarkley.com
Montreal, Canada

James Barsness
www.georgeadamsgallery.com
www.cclarkgallery.com
Georgia

Gerard Boersma
www.gerardboersma.nl
The Netherlands

Lea Bradovich
www.leabradovich.com
www.nuartgallery.com
New Mexico

Patti Brady
www.pattibrady.com
South Carolina

Bruce Cody
www.brucecody.com
New Mexico

Dennis Culver
www.doculver.com
New Mexico

Kasarian Dane
www.kasariandane.com
New York

Jason de Graaf
jasondegraaf.blogspot.com
Quebec, Canada

Gary Denmark
www.garydenmark.com
New Mexico

Harry Doolittle
www.harrycdoolittle.com
New York

Leah Dunaway
www.leahdunaway.com
Texas

William Dunlap
www.williamdunlap.com
Virginia

Joey Fauerso
www.joeyfauerso.com
Texas

Frances Ferdinands
www.francesferdinands.com
Toronto, Canada

Lisa Ferguson
www.lisaferguson.com
Noosa, Australia

Pat Forbes
www.patriciaforbesart.com
New Mexico

Phil Garrett
www.philgarrett.com
South Carolina

Cate Goedert
www.categoedert.com
New Mexico

Jylian Gustlin
www.jyliangustlin.com
California

Diana Ingalls Leyba
www.dianaingallsleyba.com
New Mexico

McCreery Jordan
www.mccreeryjordan.com
New Mexico

Sandy Keller
www.sandykellerart.com
New Mexico

Martha Kennedy
www.marthakennedy.com
New Mexico

Jakki Kouffman
www.jakkikouffman.com
New Mexico

Ines Kramer
www.ineskramer.com
New Mexico

Katherine Chang Liu
www.lewallencontemporary.com
www.jenkinsjohnsongallery.com
California

Sherry Loehr
www.sherryloehr.com
California

Catherine Mackey
www.catherinemackey.com
California

Thaneeya McArdle
www.thaneeya.com
Florida

Darlene McElroy
www.darleneoliviamcelroy.com
New Mexico

Barbara Moody
www.barbaramoody.com
Massachusetts

Keith Morant
www.keithmorant.com
Christchurch, New Zealand

Mary Morrison
www.marymorrison.info
Colorado

Tom Palmore
www.flyingpaintbrush.com
Oklahoma

Mary L. Parkes
www.marylparkes.com
New Mexico

Debi Pendell
www.debipendell.com
Massachusetts

Renée Phillips
www.ReneePhillipsArt.com
New York

Aleta Pippin
www.aletapippin.com
New Mexico

Paul Pletka
www.rivayaresgallery.com
New Mexico

Don Quade
www.donquade.com
Colorado

Nancy Reyner
www.nancyreyner.com
New Mexico

Bette Ridgeway
www.ridgewaystudio.com
New Mexico

Paul Sarkisian
New Mexico

Nancy Scheinman
www.scheinman.com
Maryland

Sam Scott
www.samscottart.com
New Mexico

Olga Seem
olgaseem@earthlink.net
California

Anne Seidman
www.anneseidman.com
Pennsylvania

Robin Sierra
www.rsierra.net
New Mexico

Daniel Smith
www.danielsmithwildlife.com
Montana

Teresa Stanley
www.teresastanley.com
California

Steve Stone
www.stevestoneart.com
Arizona

James Strombotne
www.strombotnestudio.com
California

Beth Ames Swartz
www.bethamesswartz.com
Arizona

Dannielle Tegeder
www.dannielletegeder.com
New York

Bonnie Teitelbaum
www.bonnieteitelbaum.com
New Mexico

Doug Trump
www.dougtrump.com
Vermont

Reynaldo Villalobos
reynaldovillalobos@earthlink.net
California

Jim Waid
www.jimwaidart.com
Arizona

Frank Webster
www.fwebster.com
New York

Grant Wiggins
www.wiggz.com
Arizona

Sandra Duran Wilson
www.sandraduranwilson.com
New Mexico

Dave Yust
davyust@lamar.colostate.edu
Colorado

INDEX